Beyond the lawn

All rights reserved. No part of this book may be reproduced in any form without written permission of the copyright owners. All images in this book have been reproduced with the knowledge and prior consent of the artists concerned, and no responsibility is accepted by producer, publisher, or printer for any infringement of copyright or otherwise, arising from the contents of this publication. Every effort has been made to ensure that credits accurately comply with information supplied.

Illustration designs: Keith Davitt
Illustrations: Keith Davitt
Photographs by Keith Davitt
unless otherwise noted.

First published in the United States of America by
Rockport Publishers, Inc.
33 Commercial Street
Gloucester, Massachusetts 01930-5089
Telephone: (978) 282-9590
Fax: (978) 283-2742
www.rockpub.com

ISBN 1-56496-957-6

10 9 8 7 6 5 4 3 2 1

Design: Wilson Harvey, London
[+44 (0)20 7420 7700]
Front Cover: John Glover
Back Cover: John Glover (top & middle);
Guillaume DeLaubier, right

Printed in China

Library of Congress Cataloging-in-Publication Data

Davitt, Keith.
 Beyond the lawn : unique outdoor spaces for modern living / Keith Davitt.
 p. cm.
 ISBN 1-56496-957-6 (hardcover)
 1. Low maintenance gardening. 2. Landscape gardening. I. Title.
 SB473 .D39 2003
 635.9—dc21 2002014940

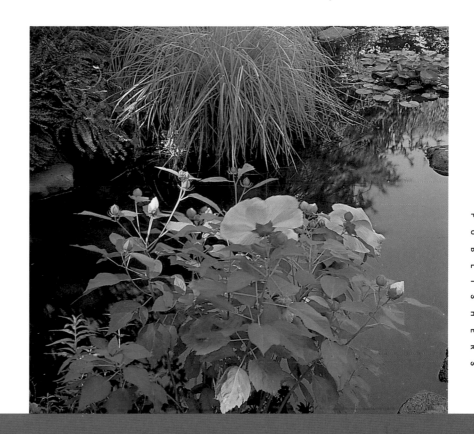

GLOUCESTER MASSACHUSETTS

ROCKPORT PUBLISHERS

Keith Davitt

Beyond the lawn

Unique outdoor spaces for modern living

Contents

Introduction

The lawnless garden

As wonderful as lawns can be, they can also consume enormous quantities of time and resources. In many areas—particularly in cities and on aboveground sites—they are not feasible or practical. And sometimes, you just want a different look. So what can be done with those spaces too shady for lawn, or where earth is lacking, or when you don't choose to make the investment of time and resources lawns require? What are the alternatives when grass just isn't right or wanted?

The many and varied answers to that questions are the subject of this book—creative solutions for nonlawn gardens. Stone and brick, gravel and water, rock gardens, ground covers, herbs, planted pots, decking, terracing, mosaics, murals, natives, and wild plants—we show how these all lend themselves to the creation of beautiful gardens without grass.

You'll learn from numerous examples of creative lawnless gardens as we examine why these solutions were chosen and why they work. In addition to aesthetic considerations in material combinations and overall design, we address practical considerations and construction details. You'll find appropriate planting schemes for each garden type and location as well as alternative elements that can be incorporated into each design. Although we present the gardens as specific types of lawn alternatives, such as gardens of stone, mixed media, or gardens with water, please note that the categories can also work together. We invite you to use these examples for inspiration and practical assistance as you create your own lawnless garden.

Stone gardens

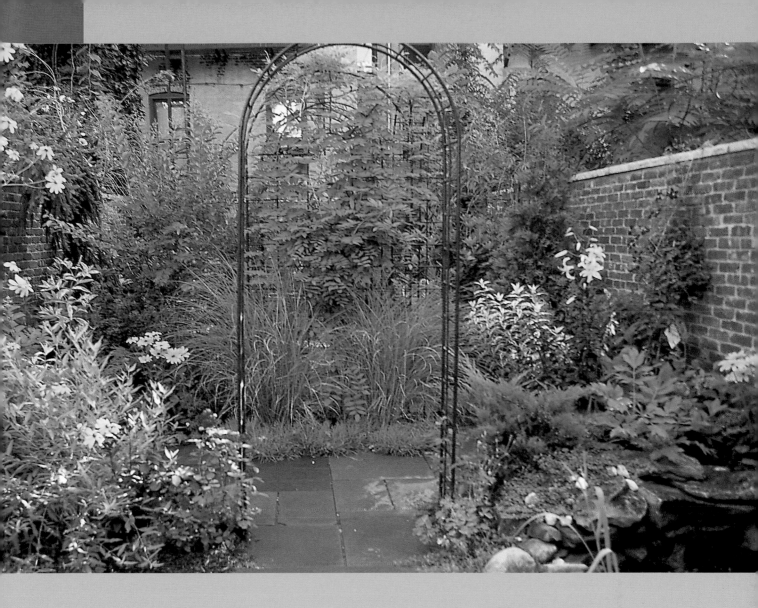

As this chapter shows, you can use many varieties of stone in place of grass. Choose a single kind of stone, combine two or more kinds, or use stone in conjunction with other materials to create attractive, original gardens.

One of the many advantages of stone as a key component of a garden is that it is so durable. It lasts forever. It is also a beautiful material, comes in countless kinds and colors, and combines beautifully with plants and other building materials. As the following gardens demonstrate, a little imagination in the use of stone can render stunning results.

Bear in mind that different countries and different regions within a country offer different kinds of stone. The specific stone used in these projects may not be available in your area, but something similar surely is.

↑ Before. Concrete and lawn formed the uninspired combination that occupied this potentially charming urban garden space.

Flagstone, pea gravel,
and a velvet gray wall

The look

This garden was dominated by lawn and concrete, and the owner didn't like either. Lawn worked—there was certainly enough sun for it—but it was not the material of choice; the owner didn't want the upkeep of a lawn, but she did want a good, solid foreground and backdrop to her beloved specimens. A hobby horticulturist with an abiding appreciation of beautiful plants, the owner wanted a garden she could both sit and move around in, a natural environment in which to care for and enjoy her botanic

favorites—altogether a wise wish for someone who works at home, loves being outdoors, and can't live without a garden. And who also loves stone.

The garden had for years been static and listless. The owner knew, however, that it could be a charming and inviting place. This required a complete revamping that included eliminating the grass and the concrete and finding a way to soften the hard lines while providing adequate structure and surfacing.

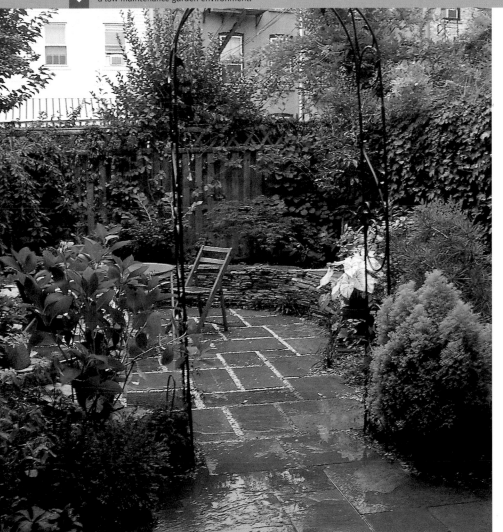

After. A flagstone patio bordered by a stacked stone wall allows for gracious outdoor living in a low-maintenance garden environment.

Just because it's hard doesn't mean it's permanent

Homeowners often look with dismay on a slab of concrete patio or a strip of cement walkway and think they are doomed to live with it forever—then are thrilled to learn that removing concrete is neither difficult nor expensive. Normally, it breaks up readily, and people can be hired to remove the debris at a reasonable cost. The concrete pieces can even be made into an attractive retaining wall when stacked with the rough edges to the outside.

The same is true of many such seemingly permanent features of a landscape. Utilities such as air conditioners can be resited, trees and tree stumps can be removed, and chain-link fencing can be replaced or attractively disguised. It is always good practice to question what at first seems obvious—to say, "Does that have to be there? Can it be moved or removed at a reasonable cost?"

It took two laborers just half a day to break up and carry out to the street all the concrete you see in the before picture. A hauler carried it off for a few hundred dollars. Once the concrete was gone, the possibilities opened up.

Because yards are generally rectangular and are often kept that way, people tend to conceive all aspects of their design in rectangular, linear terms. On the boundaries, of course, a rectangular yard will remain so—but as this and other gardens in this book show, within that rectangle, many delineations are possible. Here, a rounded patio was laid and wrapped with a stacked stone wall.

The patio stone along the outside had to be cut to fit the curve, but this too is not especially difficult or time consuming. A native flagging called New York bluestone was chosen; the flags are separated by bands of a natural, pale pea gravel. The pea gravel also skirts the retaining wall, made of another local stone called velvet grey. The wall stone harmonizes with the warm tones of the flagging and gives a comforting solid-ity and structure to the garden, while the pebbly pea gravel contrasts to pleasant effect with the flat, smooth surfaces of the bluestone. The pea gravel is laid several inches deep to ensure that the occasional drift of the pebbles doesn't expose the soil and to hinder the growth of weeds.

The planting follows the circular line of the wall and comes nearly to a closure at the arbor. The effect is to separate the garden into two distinct areas, permitting graceful passage from one to the other and creating an element of welcome; one feels invited onward into the rear garden through the rose arbor. A once listless yard is now an exciting, inviting garden—without grass.

What works and why

The stone combinations here are quite successful. The wall stone, in shades of gray and russet, blend with the predominant colors of the flagstones, while the pebbles between the flagstones create pleasing textural and color contrasts. The iron arbor (soon to be covered with roses) also works well with the stone wall.

The lattice fencing on the left is a bit raw in this photo, but it will weather to a soft silver, much like the rear fence, and will blend more naturally into the garden. It will also be covered with the flowering vines that have been planted along its length.

The planting is eclectic, as suits a genuine plant lover and exhibits a rich variety of textural values to yield a tapestry of contrasts and harmonies. Note, for example, the bold leaf of the peegee hydrangea on the left of the arbor and the fine textures of the false cypress and the Japanese umbrella pine on the right. Behind the false cypress and the umbrella pine on the right is the bold leaf of the oakleaf hydrangea, making a close contrast with those two neighbors while echoing the Hydrangea paniculata across the way. Such harmonies and contrasts always enrich a garden and, here, abound.

Variations on a theme

Any of a number of kinds of stone could have been used for both the wall and the paving to similar effect. For example, Tennessee crab orchard or other sandstone flagging types would have worked well with the wall stone and accentuated its rose and russet shades. The flagging could have been of irregularly shaped and sized pieces for a more informal feeling. Contrarily, the pea gravel between the stones could have been set in mortar for a more formal, elegant effect, or another kind of material such as concrete—or nothing at all—could have been used for joints.

Where this style can be used

This urban site, like hundreds of thousands of small urban and suburban yards, is characterized by three fences around a rectangle. The views are dominated by straight lines and harsh materials. Any such site can be transformed by incorporating more organic lines and curves, by the use of natural materials such as wood lattice and iron, by unexpected elements such as arbors and water gardens, and by abundant planting.

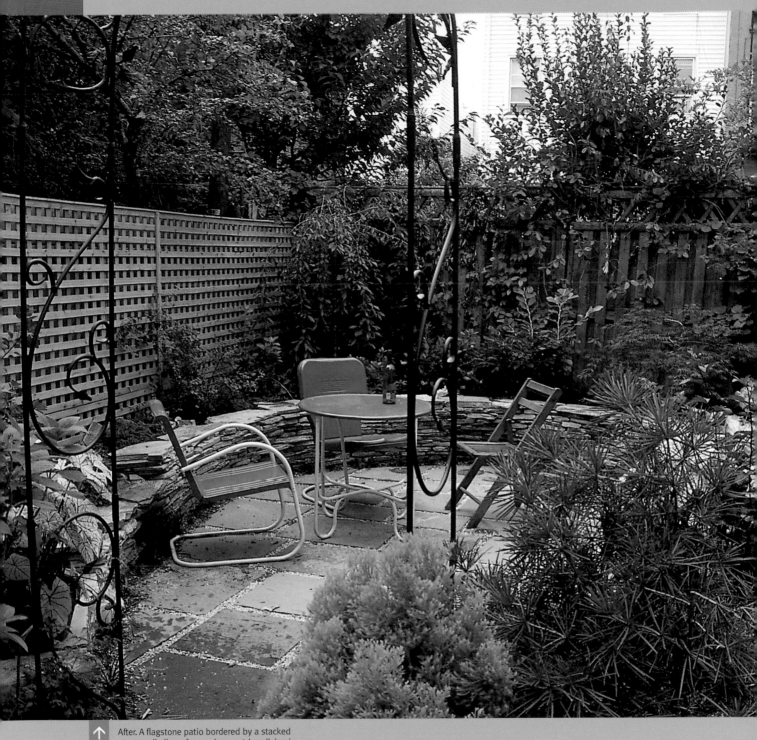

After. A flagstone patio bordered by a stacked stone wall allows for gracious outdoor living in a low-maintenance garden environment.

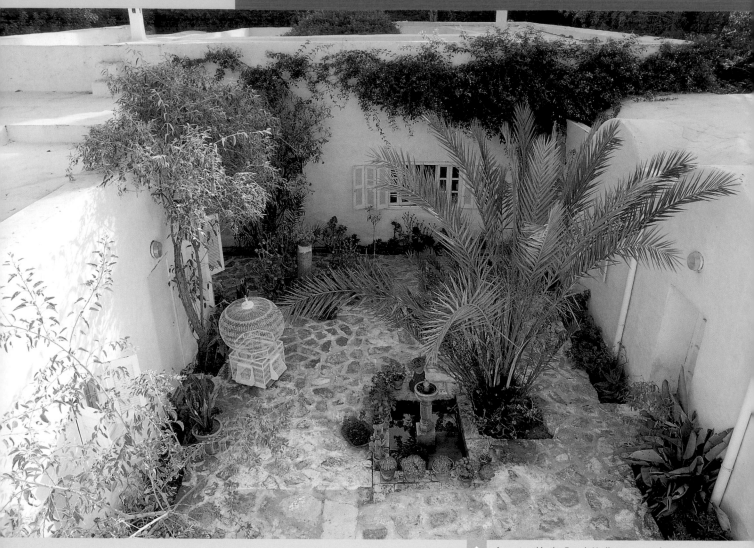

A courtyard in the French Mediterranean style is characterized by bold foliage vividly set against the plain plaster surfaces and by paving, here of stone in mortar.

A French Mediterranean courtyard

The look

Stone has long been used in Spanish and French Mediterranean gardens, particularly in the courtyards. This contemporary home with traditional court garden is a good example. With the reflective qualities of the white stucco, lawn could have grown here quite attractively but at considerable expense in terms of time and water. Random fieldstone set in mortar made an appropriate and attractive alternative.

What works and why

Outdoor living—dining, entertaining, simply lounging about or passing to and fro—are easily accommodated by the expanse of flat surface. The overall tonal value of the stone is midway between the lightest and darkest areas of the wall surfaces, so it harmonizes well and, but for an occasional sweeping, requires no maintenance.

Planting in this style of garden is critical. Too much brings too much shade, obscures the pleasant surfaces, and can be overpowering, while too little does not bring adequate softening and cooling. This is a contemporary rendering of the French Mediterranean style and the planting is a bit more sparse than might have been employed, but it is sufficient to lighten the look and cool the courtyard.

The central pool does much in this regard as well. Not only does the cool, reflective quality of the water serve as counterpoint to the hardscape surfaces, its flow over the fountain and the splash into the pool below brings a delightfully refreshing sound as if of music, slightly audible throughout the garden.

Also characteristic of the Mediterranean courtyard garden are the dramatic contrasts between the smooth stucco wall surfaces and the foliage. Note, for example, the palm. Stucco walls form a perfect background for heavily textured plants, which become the primary ornamentation, standing out as they do against the surrounding surfaces.

Sensation is in the mind

Sensory experience, such as temperature, is, in part, a psychological phenomenon. If a place looks hot, it is experienced as uncomfortable. The Moors, who had so much influence on the Spanish Mediterranean style, understood this well and were among the first to employ water in ornamental display—particularly pleasant in the hot summer. The water does cool the area slightly but, more importantly, it looks and sounds cool, and that quality is experienced in the mind, generating agreeable sensations of refreshment.

Variations on a theme

As this garden reflects a contemporary interpretation of the Mediterranean style, certain traditional elements could have been altered. For example, the planting beds along the sides of the buildings need not have been straight. If they were curved or, more appropriately to the contemporary style, had the beds extended toward the center here and there, the effect would have been both softening and more dramatic. This approach would have allowed more space for more plants and introduced a sense of motion. Similarly, another planting bed or two could have been incorporated into the patio area itself, with the paving flowing gracefully around it.

Where this style can be used

Any area contained between walls of buildings—any courtyard area—can be enhanced by a stone patio in mortar paving, with planting beds and, possibly, a water garden. In less temperate climates, or where light is less abundant, the water can be replaced by planting, by a seating area, or by a mosaic in warm tones. If the buildings are not stucco but of concrete or brick, more delicate foliage can be mixed with larger-leaved plants to soften the structures and to create harmonies and contrasts.

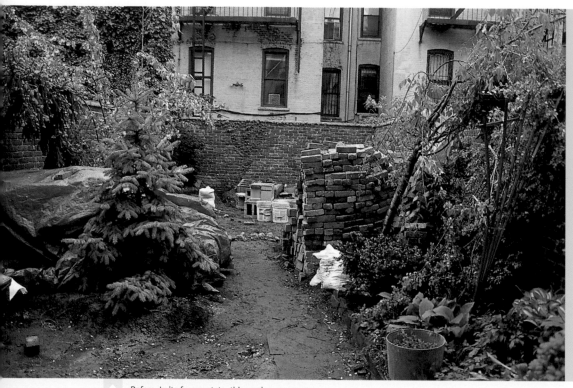

Before. In its former state, this garden space was walled on three sides with old brick. Long, narrow, open, and sunny, this represents the perfect place for a lush lawn—something the owner eschewed.

A patio garden
in three parts

The look

The length of the site beautifully suits it to division—to the creation of outdoor "rooms," each of a different nature and purpose. The front room is the informal area, situated near the house's kitchen. The place is used primarily for entertaining; it is the place where the owner enjoys breakfast or dines with guests. It is also the room he looks out on while preparing meals.

Beyond the first arbor is a small area designed for solitary contemplation, intimate conversations, reading, or just sitting in the sun. As the shrubs grow to their full size, this space will become entirely enclosed.

The meditation garden leads to a more formal fountain courtyard. Though evident from above, this area is hidden from the house at ground level. Its entrance is offset to the right. One passes through an iron pergola, covered in wisteria, and discovers the formal courtyard on the right. This area, though secluded, can accommodate small gatherings. It features raised planters inlaid with river stone and a water garden with a lion statue fountain.

The formal area is entirely symmetrical. An imaginary line bisecting the space reveals mirror images of all details. Such symmetry has a sobering, elevating effect, and an environment so composed is ideally suited to serious thought and conversation—in contrast to the free-form front garden space. The two are united by the intermediary garden.

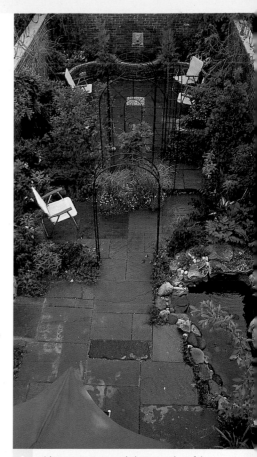

A long space was made into a garden of three connecting outdoor "rooms"—an informal garden area, a meditation area, and a formal fountain court.

After. The arbor leads to the private meditation garden.

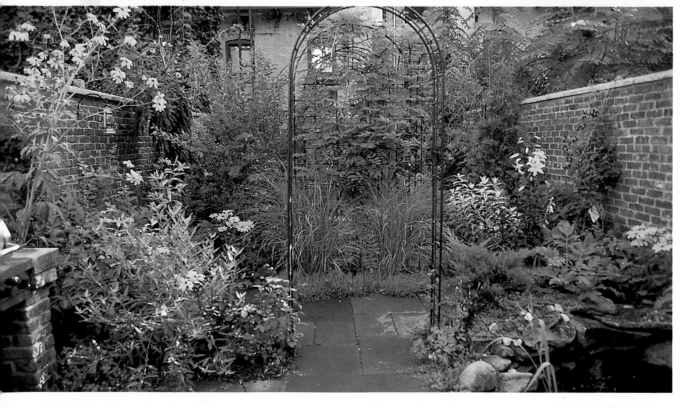

17

Enlarging through division

One of the best ways to maximize a small space, as well as make it more interesting and enjoyable, is to divide it into individual, interconnected areas, each with its own character.

These divisions can be dramatically accented, such as passing through a rose-covered arbor, or they can be subtle, marked by a simple narrowing of the path or over-hanging plants. Generally, it is best to avoid sharp distinctions between areas. Placing a gate between two outdoor rooms, for example, would make each area feel more confined and would eliminate a sense of flow. You can create a distinction between areas that are obviously joined with easy passages between them.

What works and why

Dividing a long garden into rooms is a wonderful way to maximize available space. Consider the alternatives: Had the owner of this garden opted for a single expanse of patio the length of the space, most likely it would not have been utilized. A lawn might have looked attractive, but it would have required tedious maintenance. And devoting the entire space to flower gardens would have entailed full-time professional care. Dividing the space—allotting varying pro-portions of paving and planting throughout its length, and giving each area its own char-acter—offers a range of use options with minimal upkeep.

The free-form layout of the front garden easily accommodates the grill, the table with umbrella, and the fish pond with waterfall. It also encourages guests to move from the adjacent kitchen (not shown) into this space and beyond.

The arbor, which will eventually be cov-ered in flowering vines, beckons you into the little private garden and from there hints of another garden to be discovered. Upon investigation, you'll find the formal fountain court offering a different aesthetic. Each of these garden rooms works individually, yet they are united from front to back by the enclosing structures and by the decorative wrought iron that extends along both sides and across the back.

Beyond a wisteria-covered pergola, the formal fountain courtyard is revealed.

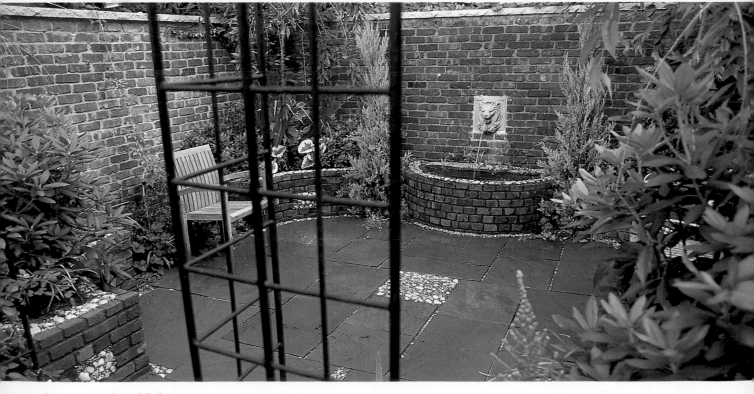

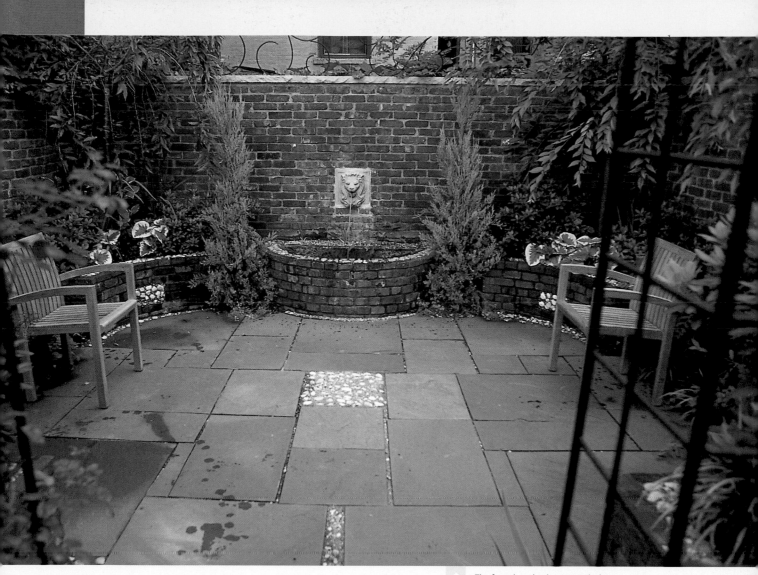

The formal garden is symmetrical
along the main axis, introducing
an air of seriousness.

Variations on a theme

The space easily could have been divided
into two rooms rather than three. In addi-
tion, the order of the rooms could have been
reversed to move from formal toward infor-
mal. The space could have been left intact
and featured a more contemporary garden.
Rooms with other functions could have
been designed—for example, a play area for
children, with bark chips or sand for a base.

Where this style can be used

Any long, narrow site can benefit from the
space-division approach, as can square-
shaped gardens. Many urban settings as
well as suburban and townhouse outdoor
spaces lend themselves to this design style.

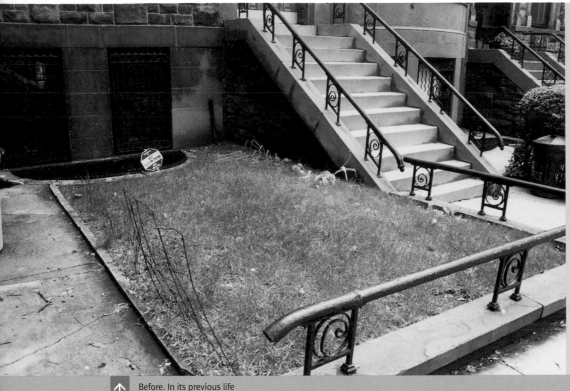

Before. In its previous life this urban lawn was neither attractive nor useable.

From mundane ^{to} elegant

The look

Not only was grass neither practical or usable in this front yard city garden, the owner specifically had an aversion to lawns. The daughter of a gardener, and a gardener herself, she preferred shrubs and trees and perennials and besides, she needed space in which to manipulate a baby carriage, to sit down and regroup, and to chat with departing company. She also wanted to screen the necessary utilitarian functions the area must accommodate; for this reason, raised beds were designed to hold a variety of trees, shrubs, and perennials, behind which various receptacles could be hidden.

The walkway, the lawn, and the separation between them were removed, which opened the space. Planters, built in brick with New York stone coping, were designed to screen the rear corner of the property and were carried forward and outward in tiered fashion toward the gate entrance for balance. The gate and railing were redesigned, a gas lamppost was installed, and New York stone paving was placed on stone dust in the remainder of the surface area.

What works and why

A rather messy and poorly divided space requiring regular upkeep and offering little usefulness is now characterized by clean lines, an open aspect, and a simple elegance. The space is now usable as well as attractive and, with the addition of a discreet drip-irrigation system, easily maintained. Brown brick was selected to harmonize with the brownstone of the building and the stone coping and paving to harmonize with the brick. The planters were kept small, in scale with the space they occupy, and planted primarily with broadleaf evergreens—Pieris japonica (andromeda) and Kalmia latifolia (mountain laurel), which provide year-round screening—highlighted with Hydrangea macrophylla (big leaf hydrangea), a fragrant viburnum, and ferns. Variegated vinca and euonymus trail over the edges and bring touches of brightness. The two dominant trees are a weeping redbud and a weeping cherry; their dangling branches further screen unwanted views without growing too large for the space.

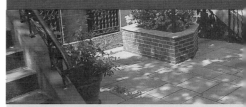

The joys of weeping trees

Weeping forms of trees and shrubs have long been used to create dramatic, emotional, and romantic effects. In this role, they are superb. They also have a practical use, however. Whereas we normally plant shrubs and trees to grow upward to hide some undesirable view, weeping forms can be counted on to grow downward to perform the same job while conveying that graceful, softening aspect we so enjoy them for.

↓ After. A graceful, elegant, and functional cityspace.

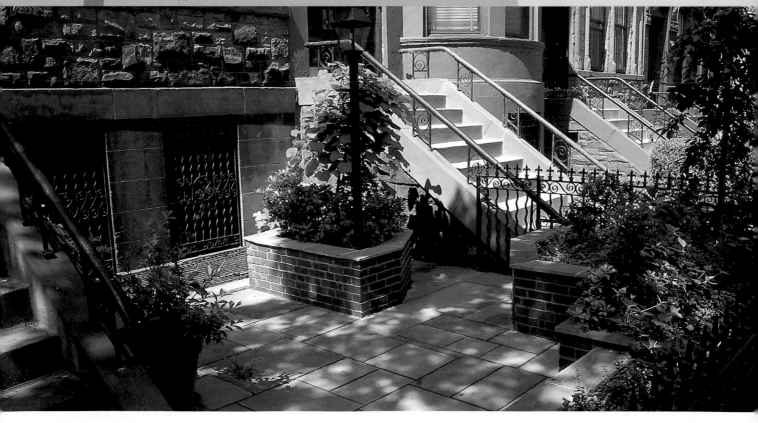

Variations on a theme

This design could be modified in many ways while maintaining the general motif. The planters could be of a different material, such as Pennsylvania fieldstone or even brownstone, and built in different shapes and sizes. The paving also could be of another material, such as Tennessee crab orchard, and an entirely different planting scheme could be as effective.

Where this style can be used

This is certainly an urban garden, but the approach need not be confined to the front; a rear plot could be treated effectively in this style as well. Where more space is available, simply scale the design up, using more and perhaps larger planters; for a smaller space, scale downward.

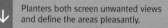
Planters both screen unwanted views and define the areas pleasantly.

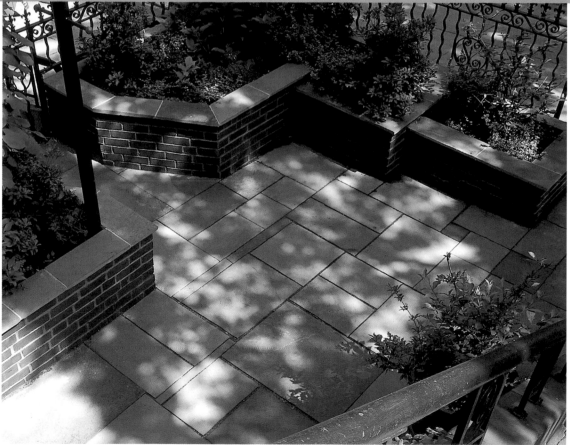

Alternative stone garden designs

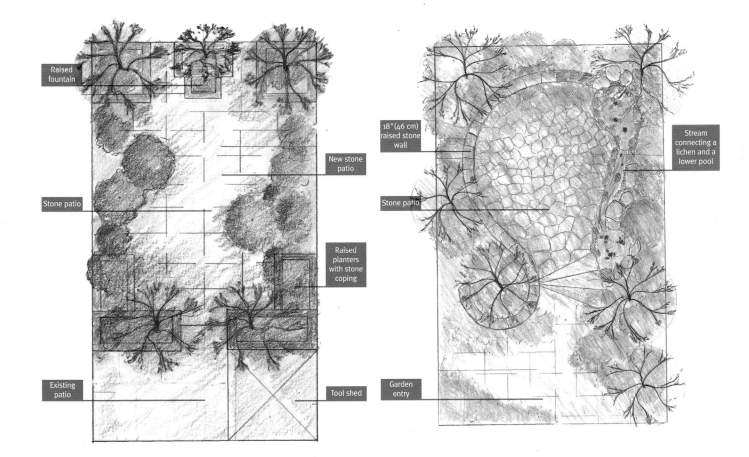

Raised fountain

18" (46 cm) raised stone wall

New stone patio

Stream connecting a lichen and a lower pool

Stone patio

Stone patio

Raised planters with stone coping

Existing patio

Tool shed

Garden entry

↑ A formally symmetrical exterior structure of raised planters was given an informal layout of a stone patio bordered with free-form planting beds. A tool shed occupies the front right corner and a raised fountain the center rear, overhung with an ornamental dwarf tree.

↑ A curving raised-stone retaining wall sets off a sunken patio of random shaped and sized pieces of paving stone. A small pond is connected by a stream. Steps lead up to a raised stone patio overlooking the sunken garden.

Green solutions for grassless gardens

Lawns are often meant only to be seen and not used. In such situations, a variety of plants other than grass can be used both to reduce upkeep and to offer a completely different look and feel. Such solutions are as appealing as grass, or more so.

If, on the other hand, some degree of use is inevitable, consider planting one of the various low ground covers that will bear foot traffic. Such an approach makes possible a garden space that is not only interesting and distinctive but usable as well. Here, we look at several gardens that rely on plants other than grass for their greenery.

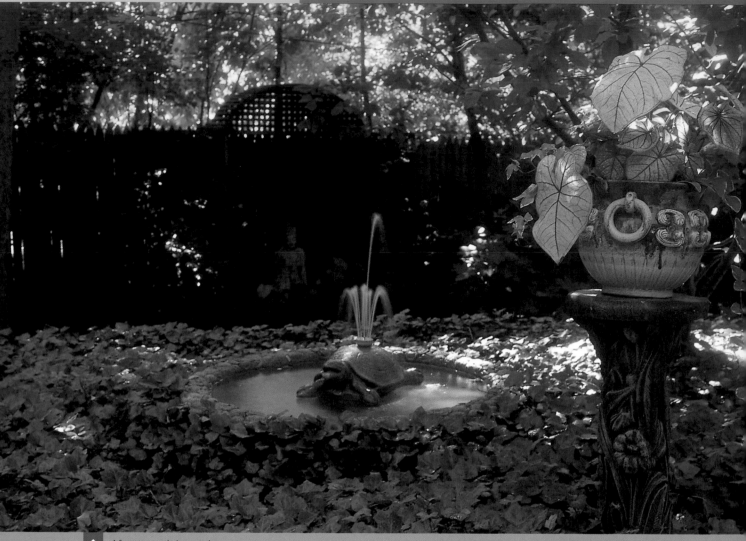

A few structural elements in a sea of leaves form a peaceful, well-balanced garden of greenery.

Peaceful verdure in dappled shade

When creating a plain or simple garden, it is important to include elements of interest, however few or unimposing. This gives the eye a place to settle after traversing the garden. A simple garden can be pleasurable and quite soothing, but without distinctive visual components, it risks becoming tedious. A bench, a small sculpture, even the placement of a good-sized rock can perform this essential function.

The look

The owners wanted to create a peaceful place to view from slightly distant vantage points. They wanted something spare, yet interesting enough to attract the eye and satisfy the senses. Taking a simple approach, they planted ivy over the entire area and added select elements as ornament.

Planting grass was not an option because of the extreme shade from neighboring trees. In fact, the shade is so intense that not many ground cover plants can thrive here, and certainly none more successfully than ivy.

What works and why

Able to thrive in dense shade and compete successfully with tree roots, requiring little care and no mowing, ivy was an excellent choice for this site. However, not only the ivy makes this garden work. Quite the contrary—if this entire space had been given over totally to ivy, the garden would have been dreary and utterly without interest. Several elements prevent this from being the case.

The designer knew when he created this garden that ivy would give the wanted verdure but that an expanse of any ground cover, and especially a leafy mass of ivy, requires solid contrasts to balance and offset such an extent of foliage. So he built structure into the garden.

Most notably, he installed a water garden in the dead center of the garden; it became the place to which the eye is first and last drawn. The durable concrete basin and turtle sculpture are welcome forms to find in this sea of leaves. The water itself offers a visual contrast to the ivy, and its lively motion points out the calm of the garden's overall mood.

Taken as a whole, this is a wonderful example of a grassless garden. It is a serene environment as green as any lawn, yet far more engaging. The best part? Except for occasionally skimming the pool and keeping ivy off the trees, no maintenance is required.

Variations on a theme

Pathways would make the scene a bit more inviting but might compromise the serenity the garden conveys. Vinca major or minor (periwinkle or myrtle) and wintergreen are alternative evergreen ground covers that will grow in deep shade. Gaultheria (wintergreen) is a handsome plant with red berries, but it is sold in individual pots, not flats, and would be expensive. The low shrub Sarcococca humilis is also a dark evergreen that could be used and has an inconspicuous but fragrant flower. Finally, a variety of plants, if well chosen and laid out with one area of a species running into another, could also be effective. For example, a planting of vinca in part of the garden, perhaps laid out in a particular pattern, and ivy or another ground cover in another section could increase visual interest without detracting from the serenity of the garden.

Where this style can be used

Any place where actual use of the space is not a requirement and there is considerable shade would lend itself to this sort of treatment. Unused lots between urban buildings that are seen from windows and walk areas are great candidates for this type of garden.

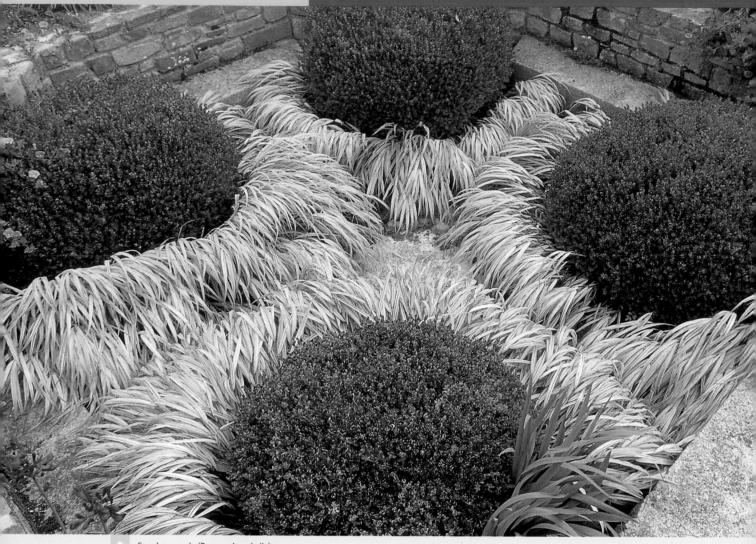

Four boxwoods (Buxus microphylla)
wearing skirts of ornamental grass
provide more interest than a mere plot
of grass would.

Symmetry in a
sunken court

Combining plants

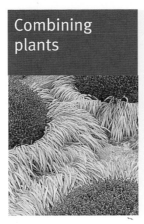

All too often, gardeners combine plants that have no clear relationship to one another. A good rule of thumb: If plants grouped together don't work in harmony or form a pleasing contrast, they should not be combined. Creating an attractive mix is easy.

For example, a small-leafed plant, such as a boxwood, and a large-leafed plant, such as rhododendron, form a contrast. The yellow and green leaf of variegated iris and the yellow and green leaf of variegated Hosta fortunei harmonize while the leaves' shapes yield a distinctive and pleasant contrast. When plants both harmonize and contrast with one another, their combination creates the greatest impact. Similarily, a variegated iris combines beautifully with variegated hydrangea because the leaves contrast in form but harmonize in color. The dark, glossy leaf of many types of holly is similar in appearance to the leaf of the Gaultheria procumbens (wintergreen), but one is a large shrub, the other a creeping ground cover. They harmonize in leaf qualities but contrast in overall form and are lovely to see together.

The look

This symmetrical but relaxed planting arrangement is perfect for a small space that isn't used but should remain green and attractive. Boxwood shrubs occupying the corners of the garden in a distinctive four-square pattern were given skirts of an ornamental grass (Hakonechloa). The plants are sunken and surrounded with a low stone wall.

What works and why

The owners wanted people to view their small garden as if it were a picture, so they framed it with a wall. The result is a simple, attractive scene in a familiar design—uncomplicated, yet not without interest.

The marked foliar contrast between the grasses and the boxwood distinguishes this space with both color and form. Not only does the light yellow of the grass contrast with the dark of the boxwood but also its loose, arching form is practically opposite to the rigid form of the upright boxwood.

Variations on a theme

Although the overall design is smart and a distinctive contrast exists between the foliar values, the planting scheme could be effectively modified. In place of the boxwood, plants with larger leaves could work well with the wall—as, for example, any of the large-leaved hollies, Osmanthus, or compact varieties of rhododendron. For an infusion of color, hydrangea is an attractive choice. A variegated variety of hydrangea would form a harmony in color and a contrast of form with foliage of the hakone grass. To tone down the contrast, try spotted dead nettle, or Lamium maculatum, instead of grass.

Where this style can be used

This is an excellent paradigm for any small area that exists to be seen, not used—especially in a formal garden where pattern and geometry are important.

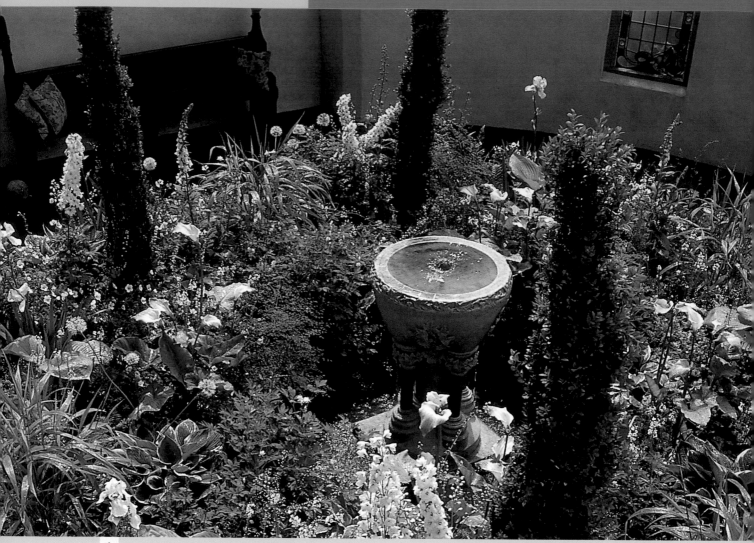

↑ This invitingly cool courtyard garden in green and white features a water basin in the center.

A cool courtyard in white and green

The look

Here is a courtyard garden that does not require less upkeep than grass but offers a great deal more interest, beauty, and enjoyment. Stone paving surrounds a particularly rich planting bed in a circular design, at the center of which is a formal fountain. This is a green and white garden, among the coolest as well as the most elegant of garden styles. Various seating areas and access points surround the garden, allowing it to play the roles of both haven and focal point.

What works and why

This motif is excellent where a pleasing vignette is wanted to provide enjoyable experiences within an environment replete with visual and aural refreshment. The garden room is meant to be enjoyed through the senses in a more passive manner than the same expanse in lawn would elicit. One doesn't gambol about here but, rather, moves peacefully through pleasant gardening duties or simply sits or strolls, enjoying the cool elegance of the scene.

The planting is particularly rich in harmonies and contrasts in color, texture, and form. The large expanses of plain building surfaces easily offset the eclectic diversity of the planting. Mere lawn here would not provide sufficient balance to such surroundings, which need the softening effect of flower and foliage. In addition, the textural contrasts of the outer paving, the inner planting bed, and the central stone water basin are gracefully balanced.

Whereas the leafy masses of abundant foliage contrast pleasantly with the surrounding structures, they would be formless without the vertical plinths of the clipped boxwood and the solid structure of the stone basin. Taken together, the elements of this garden weave a rich tapestry of well-ordered contrasts.

Harmonies, too, are abundant, particularly in the bright bursts of white that seem to dance through the garden. The light margin of the hosta leaps into the many flower displays and is echoed in the stone basin and the surrounding walls; their bold leaves, in contrast to the fine textures of the foliage and blossoms around them, harmonize with the flat surfaces of paving and walls. The various plant types are rhythmically repeated throughout the garden, binding it into a unified whole.

Variations on a theme

Little fault can be found with this garden—possibly more of the larger leaves, such as those of the hosta, dispersed throughout the garden would soothe and slow the energetic quality of the many fine-textured plants. The vertical accents might work better and be less sharply contrasting if broader and lower but, on the whole, this is a fine composition. Different plants could have been used not to better but to different effect.

Where this style can be used

This is an excellent lawn alternative for any courtyard-type garden of relatively small proportions. Its overall shape should be governed by the shape of the enclosure, but it need not repeat the shape. Here, a circular garden works well in the curving space surrounding it, but a rectangular garden could also work as a contrasting form (as could a round garden in a rectangular space). The proportional relationship of the garden and its enclosing space is more important than the choice between contrast or harmony of form. The garden area shouldn't crowd out the walk and living space around it, nor should it seem too small in relation to its surroundings.

The relativity of size

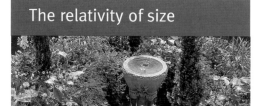

A given space or an element within a space will seem larger or smaller depending on its proportional relationship to its surroundings. If, for example, a tiny garden is placed at the center of a moderate-sized area, the garden will appear even smaller than it is, and the space itself will seem enormous. If a centrally placed garden is made more than half the size of the area around it, the garden will seem huge and the space quite small, though it may be ample. If instead the garden is made to occupy about half or slightly less of the area, both it and the surrounding space will seem plentiful.

Alternative grassless garden designs

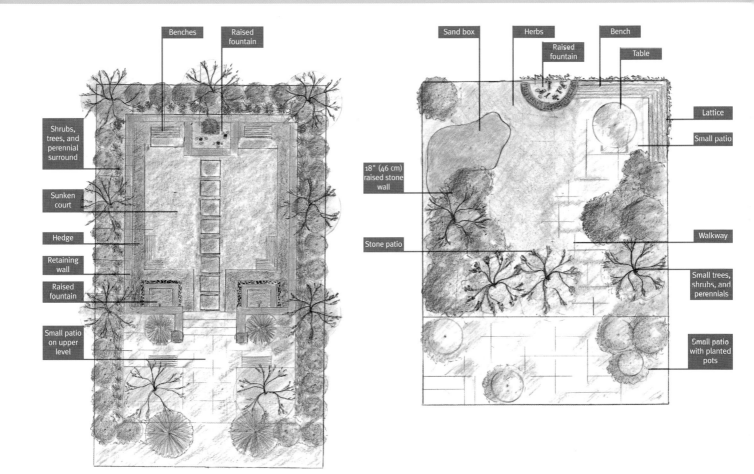

Benches

Raised fountain

Shrubs, trees, and perennial surround

Sunken court

Hedge

Retaining wall

Raised fountain

Small patio on upper level

Sand box

Herbs

Raised fountain

Bench

Table

Lattice

Small patio

18" (46 cm) raised stone wall

Stone patio

Walkway

Small trees, shrubs, and perennials

Small patio with planted pots

A small patio overlooks a sunken garden paved in herbs and enclosed by a wall and hedges. The raised fountain to the rear contains a built-in planter and is flanked by seating benches. The raised fountains to the front are bordered in a pebble base. The planting is almost exclusively green with blue highlights.

A walkway winds out to a small herb garden with sandbox, small patio, bench, and raised fountain. The whole is enclosed in small ornamental trees, shrubs, perennials, and vines on lattice.

Mixed media

Mixed media

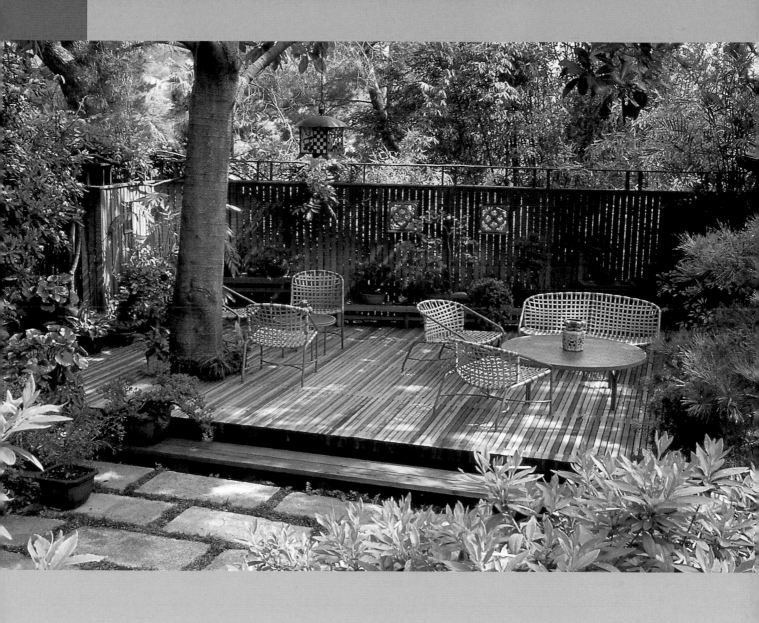

Often, the best solution for a garden without grass is the combination of two or more materials into a unified composition. The result can express dynamic contrasts—stone and water or wood and stone—or can form harmonious blends, as will occur, for example, with several different kinds of stone combined. This approach allows for considerable diversity within a single vignette. Our appreciation of each component of the composition is refreshed as our vision moves from one element to another.

It is important that the materials work well together. Not all materials in combination show to advantage. In general, seek either a notable contrast or a definite harmony, or both. The relationship among the materials should be both evident and flattering. Otherwise, the materials should not be used together.

Here, we look at several mixed-media compositions, from simple to elaborate. Together, they span a range of possibilities and offer a wealth of ideas from which to draw.

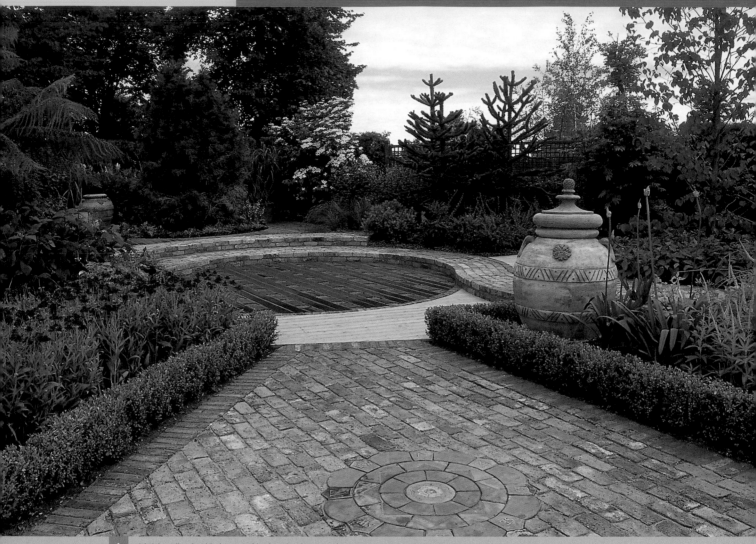

A brick walk edged in boxwood hedges leads to a pale wood deck, which then leads to a sunken area of dark wood and chips, creating a garden of many contrasts harmonized through textural values.

Texture in harmony

The look

Looking out on this site, we would expect to see an expanse of lawn bordered by planting beds and, perhaps, to the rear and sides, some tall shrubs or trees. And the view would have been attractive. But how much more exciting, how refreshingly different, is this composition!

This space features a brick patio laid in a running bond pattern and bordered by boxwood. At its center is a tile mosaic sundial. The patio leads to wood decking set perpendicular on the same plane. The decking is bordered on one side by sets of the same brick. A brick walkway picks up the line and completes the circle.

One step down is a checkerboard pattern of dark gravel alternating with squares of a different wood from that of the foreground deck. The brick walkway that borders half the checkerboard steps up, repeats, and is then bordered with another decking of yet another kind of wood. To the sides and center are mulched and pebbled planting beds with strategically placed terra-cotta pots.

What works and why

This degree of variety in a single setting is exceedingly difficult to carry off—but it succeeds here. The first and most noticeable thing about this garden is its striking contrasts. Notice the brick along the box-wood hedge, the brick against the light wood decking, the light decking with the dark, the dark against the charcoal gravel and the light stone beyond, the walkway of light brick before the darker wood beyond, and the soft foliage in contrast to all this. Each of these are successful contrasts. But the key to the success of this garden is what unites its various elements.

Most important are the textural values. All the paving elements are of a medium to rough texture. The three kinds of wood, the brick, the gravel, and the terra-cotta are united through this aspect—they have the same tactile value, and we feel that similarity, that harmony.

Second, the components are united through harmony of line. The first brick area reflects the line of the sunken wood and gravel area and the decking beyond. Its circular mosaic repeats the curves of the walkway, the sunken area, and the distant planting bed. This curving line, found throughout the garden, weaves all the areas into a single composition. Finally, the various components are embraced by, and contain within them, plantings, which also brings unity to the garden.

Getting outside the garden box

The typical backyard garden, a lawn bordered by shrubs, is nearly as familiar to us as a rectangular room, but once you discard that paradigm, the world opens up. Unlike an indoor room, a garden need not conform to a modular format and, thus, can become any type of space your imagination can conceive. Many of the gardens featured here demonstrate the success of liberated garden thinking. To explore new possibilities, clear your mind. Allow yourself to think freely. This helps break through the walls of tradition and enlarges your capacity to design from a fresh, creative perspective.

↑ The sundial resonates through color with the distant surfaces and by form with the central, circular portion of the garden.

 Though surfaced in five materials, the garden expresses the harmony of the textural qualities that bind it.

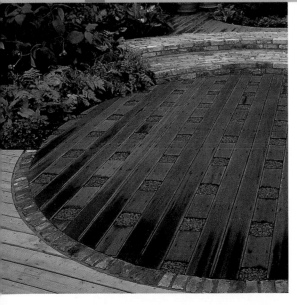

Variations on a theme

To tone down the contrast in the checkerboard pattern, you might want to use flat pieces of charcoal-colored slate or stone in lieu of gravel. This approach will still provide contrast in material and color while harmonizing with the surface area.

Where this style can be used

This is an expensive garden that occupies a fairly large plot, so its design could be difficult to reproduce. However, the design principles that make this garden a success can be applied in any garden where surface paving plays a significant role.

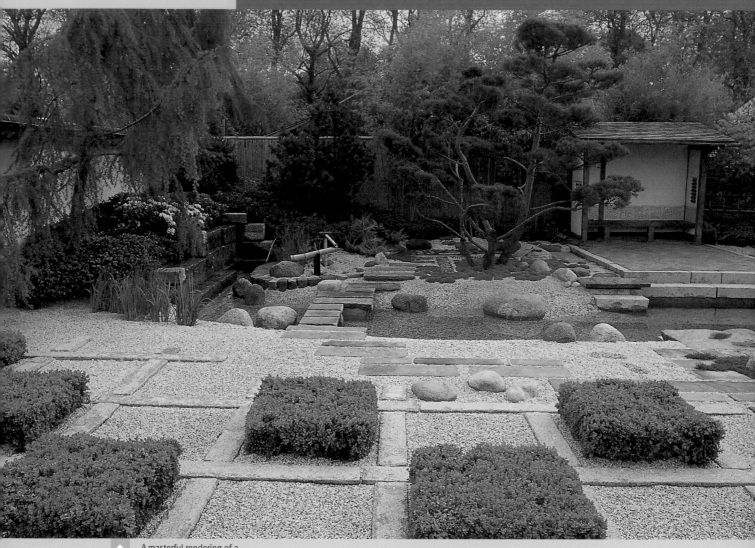

A masterful rendering of a contemporary garden in the Japanese tradition.

Mixture of materials

The look

A sublime working of materials forms a complex yet serene setting, any portion of which might have been done in lawn. This is a contemporary Japanese garden, rich in variety yet united through common qualities, as discussed below.

The front area is reminiscent of French parterre work, with its clipped box in regular arrangement, yet it is imbued with an Asian character through the stone pavers, gravel, and river stone. Stepping stones lead to a bridge over a clear pool with a contemporary feel, beyond which are several classic Japanese elements. A chozubachi, a traditional fountain with water flowing through bamboo into a stone basin, is to the left, while to the right is a traditionally sculpted Japanese pine with rocks and ground cover beneath. This area leads to a contemporarily formal patio with a more traditional shelter to the rear from which one can view this entire and entirely captivating landscape.

What works and why

Taken as a whole, this is a contemporary garden in the Japanese tradition, or a Japanese garden rendered in a contemporary style. It is rich in variety yet united through several qualities, the most predominant of which are its remarkably clean lines and surfaces. The impression is that these areas were created, then brushed with a unifying sheen that eliminated all disparity. The smooth patio edged in polished granite block; the low, uniform ground cover beneath the sculpted tree; the flat stepping stones; the perfectly clean lines and uniform surfaces of the boxwood, gravel, and granite foreground and the round smoothness of the river stones are all wed through a purity of line and surfaces. By this quality, the entire garden, with its many vignettes, is melded into a single place.

The other primary factor that unites this landscape is its balanced repetition of materials. The green of the box is echoed in the ground cover beyond; the granite pavers around the box are reflected in the patio edging; the gravel and river stones are found on both sides as well as in the middle; and the pool both separates the primary halves of the garden and unites them, washing both shores with its delicate purity.

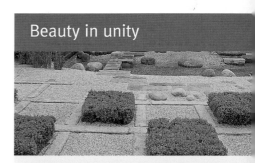

Beauty in unity

Cityscapes can be enormously unattractive—empty lots with chain-link fencing, trash cans, and construction debris surrounded by unrelated, often harsh building styles. After a snowfall, however, the same scene is suddenly beautiful. Why? The answer is not the addition of snow; it is the elimination of the unsightly disparities. The scene is unified by the uniform covering of snow.

The prevalence of lawns probably is due to their similar unifying quality. Lawns provide a relatively large expanse of uniform surface that bonds the elements of the environment; this unifying quality is crucial to any work of art. But landscape unity can be achieved in many ways. Any design stratagem—for example, the repetition of forms, materials, textures, or colors—that brings the elements of a composition into harmonious relationship with one another generates this quality of unity.

Variations on a theme

This is altogether a masterpiece of design that permits, at least in these pages, no suggestion of change.

Where this style can be used

Anywhere space permits and tastes dictate a melding of contemporary styles with traditional Japanese design, such a garden would be a blessing. Ensure only that its design is undertaken by a master, as its success cannot be achieved by the average homeowner or, indeed, the average garden designer.

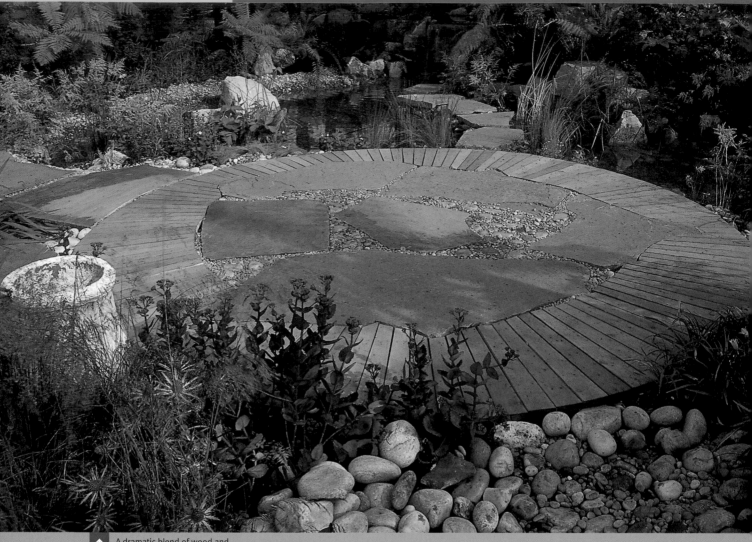

A dramatic blend of wood and stone, water and pebbles.

Wood and stone,
water and rock

Every material produces its own effect

When determining the composition of a garden, consider the impact of every material and choose only those compatible with your nature and garden's motif. Brick, stone, concrete, wood—these all have different influences. If you are a light and airy sort, inclined to springtime colors, you might not want heavy stone or concrete. If you like mass and solidity and are also of an organic, outdoor nature, stone might please you but concrete not. If you are comfortable with city life and urban realities, iron, steel, and concrete might be perfect. Never choose or accept materials because they are handy, available, or cheap. Their influence can be powerful and persistent.

The look

A distinctive combination of materials creates a terrific substitute for lawn. The centerpiece and focal point of this garden consists of large, irregularly shaped pieces of flagstone with small, washed stones and gravel between. These pieces are bordered by wood slats cut to fit against the angles of the stone on the inside and to form a round walkway on the outside. The central dais joins to a stone bridge that crosses over a small pond. Various stones and plants border these areas and are randomly distributed throughout.

What works and why

The overall unity created by the repetition of relatively rough textures throughout the garden is pleasantly accented with a seemingly endless variety of contrasts. The large slabs of flagstone contrast with the bed of gravel in which they are set. The wood slats show distinct color contrasts, as do the flat wood and the rounded river rocks in the foreground. The water contrasts pleasantly with the paving surfaces, and the plants everywhere set off the other elements by form, color, and texture.

Variations on a theme

This landscape offers considerable scope for variation. The center area could be another shape, comprise different stones or different elements entirely, or bordered with a material other than wood. The space now occupied by the water garden could have been made a perennial bed, the plantings of which could be varied infinitely.

Where this style can be used

This is not an easily adapted approach. Considerable space is needed to accommodate such a variety of elements and the bold use to which they have been put. This is also a strongly structured landscape; there must be a taste for heavy, solid elements and the opportunity for a backdrop of heavy planting for balance.

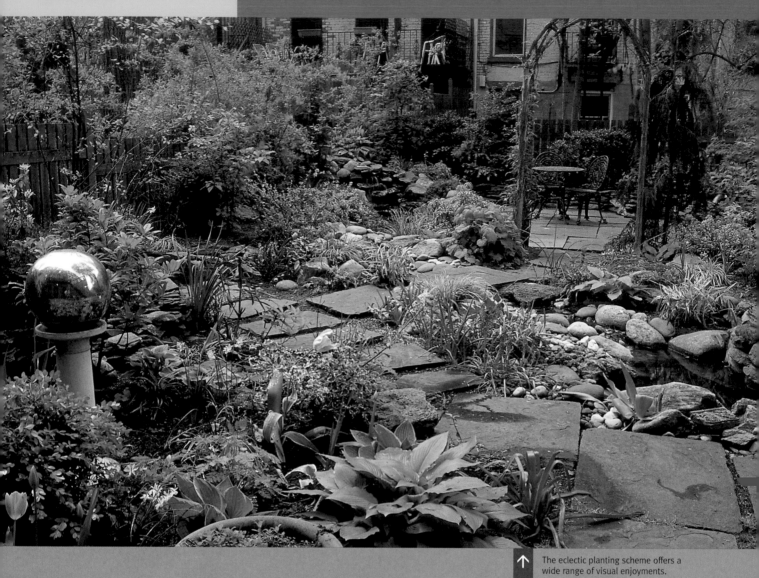

The eclectic planting scheme offers a wide range of visual enjoyments.

Rough
and rustic

The look

Patios, plants, stream, pools, and plinths—the components of this garden—combine to create a rustic look of many textures and hues. Its striking impact comes from is contrast to the urban world surrounding it. We just don't expect such a natural setting in the heart of a city.

What works and why

For people who experience city life as stifling, predictable, and symmetrical, who want to escape to a world untouched by modern regularity, this garden does the job. Designed to look undesigned, the garden feels like a random arrangement of spaces carved out of a setting dating to pioneer days, with a haphazard touch of ornament here and there. The pools and stream may always have been here, for all we know, the patios laid down as a matter of convenience, and the twig and log arbor thrown up for a little decoration. The planting is clearly unplanned, with a this here and a that there, contributing to the relaxed, natural feeling of the place.

Yet for all this nonplanning, this landscape really is a rustic world offering a variety of experiences. The waterfall provides the dimension of sound, the pool supports fish and aquatic plants, and the stream gives us that ever-delightful element of water flowing over rocks. The eclectic planting gives a range of texture, leaf color, and blossom; the front patio a place to sit and look out over the garden; and the rear patio, reached through the arbor, a place to dine.

Variations on a theme

Had a less random, more organized look been wanted within a yet naturalistic setting, simply altering the line of the path to form a graceful curve between the two patios and over the stream would have done much. As it is, the straight line in one direction forming a right angle to the path from the other patio implies an accidental route. Likewise, a planting scheme with fewer species or with the plants more grouped by species would have rendered a more ordered environment.

Where this style can be used

This basic approach—a rustic environment composed of natural elements—can be applied anywhere such an influence is wanted, but it would probably work best in a suburban or even rural setting where surrounding elements are not in such stark contrast. In an urban setting, the taste for a naturalistic, woodsy garden must be very great for this to be completely satisfying.

Beauty is in the mind of the beholder

As has been often pointed out, it is in our nature to seek variety and to attempt to balance extremes with their opposites. Artificiality, routine, and predictability—often characteristic of modern existence—elicit a desire for nature, random phenomena, and the unfamiliar. A garden composed of these qualities can be a beautiful thing to the captive city dweller where, to one accustomed to living closer to nature, such a garden might seem a bit unkempt.

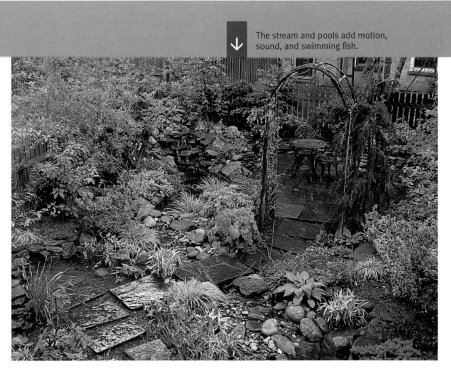

↓ The stream and pools add motion, sound, and swimming fish.

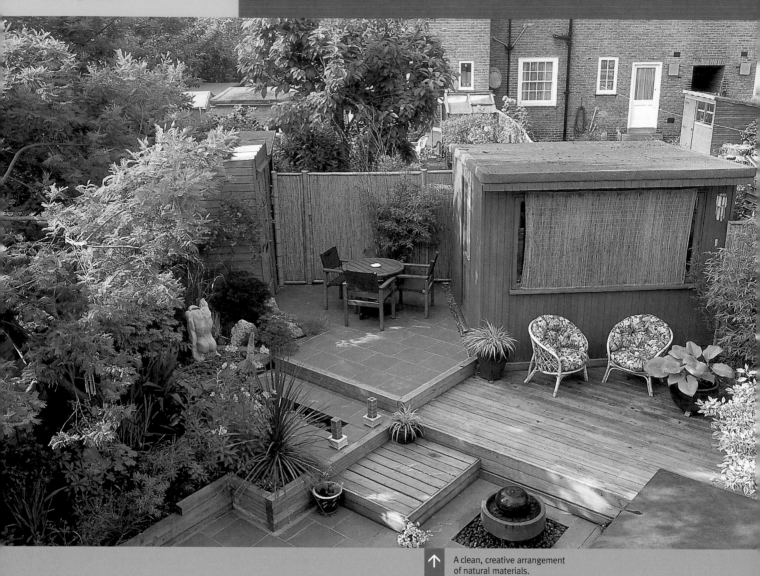

↑ A clean, creative arrangement of natural materials.

A contemporary
composition

The look

This space presents an enclosed backyard terraced into several elevations and paved in rhythmic patterns of alternating stone and decking. Ceramic accents in the form of planters and a water feature bring a glossy gleam to the garden and add bold strokes of blue, while plants distributed lightly throughout and along the patio margins soften and enliven the scene.

What works and why

This striking garden generates its effect by juxtaposing a variety of elements. The arrangement is completely contemporary and geometric, with not a single curve to be found, yet it is made entirely of earthy materials—thus constituting an inorganic composition through natural media.

The materials themselves alternate between wood and stone in repeating rhythms, with ceramic highlights. The stone and wood harmonize in roughness but contrast in hardness and color, while the ceramic planters provide a sharp, but not excessive, contrast to both. The water flowing smoothly over the ceramic ball into

the stone basin adds yet another pleasing textural contrast to the paving and structures. At the same time, it reflects the ceramic planters and accentuates the contemporary theme.

Though its relatively small space is terraced into four elevation changes and several distinct areas, the garden does not seem restricted. The graceful flow to and from one elevation to the next, the repeating lines, angles, and materials bind the whole into a gracefully expansive, multidimensional landscape.

A modern water feature brings a pleasant textural contrast to the setting.

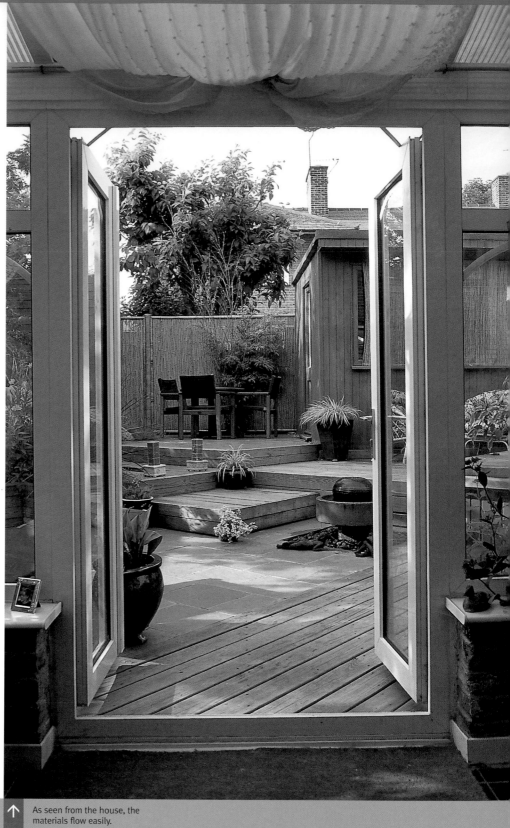

↑ As seen from the house, the
materials flow easily.

Clarity of intent is the key to consistency of design

When a clear concept guides a design, the result is cohesive and consistent. Each element contributes to the whole, giving the design a definite sense of place. This establishment of unity is of the utmost importance. The simpler the design, the more easily unity is achieved, yet unity can still be created within a more complex motif. For example, a contemporary design rendered in natural materials may be said to be a two-level design concept, yet as long as the lines, planes, surfaces, structures, and materials employed are generated by the design, are consistent with it and not placed for convenience or some arbitrary or conflicting notion, the design will hold together.

If, on the other hand, the design is confused or undecided in the look being sought, this will show in the built garden. One element or line will contradict another, one effect will cancel another, and the result will be confusion and disharmony.

Variations on a theme

To maintain the style and effect of this composition while gaining more living area, the upper stone, upper wood, and lower stone areas could be made larger and the intermediate wood and stone step platforms made smaller. For example, the upper stone platform could be extended into the adjacent stone area and the upper wood platform extended into the wood step below it. Similarly, the lower stone patio could encroach on the lower wood step.

Although these materials work well together, different woods and paving stones could prove equally as effective within the same general layout.

Where this style can be used

A site that can incorporate this design must have room for elevation changes (though a total of 2 feet (61 cm) in elevation difference will do) and space to accommodate the platforms. Many city gardens are candidates for this style; the geometric layout can be easily adapted and the use of natural materials gratefully received.

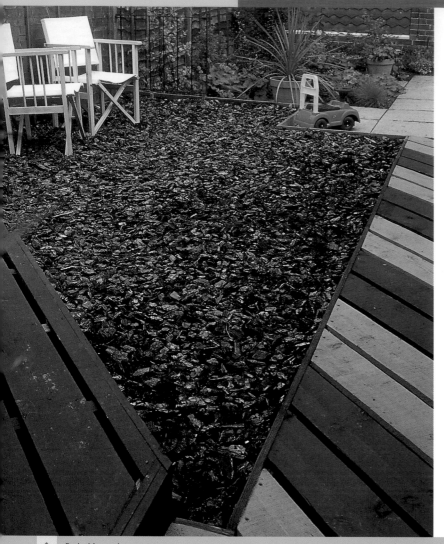

↑ Bark chips make an
inexpensive, serviceable
space suitable to many uses.

A chipped
children's
garden

The look

Here is a remarkably simple, inexpensive alternative for a children's play area. Rather than trying to maintain a lawn, which would become damaged and worn from vigorous play, the owners laid down bark chips within a wooden frame. The area is bordered on two sides by wood decking, on one by a fence, and on the fourth by a planting bed.

What works and why

This may not be the most visually stunning garden area, but it certainly is among the most practical—and on the whole, it works aesthetically as well. Though simple in composition, the angles created by the wood decking add an element of drama and sophistication to the site, as does the unusual color scheme. The materials alone would have made the space mundane, but the clever, satisfying line and color treatments prevent this. The arched iron grate between the chipped area and the planting area also contributes to the scenic effect.

The attribute of sophistication

The term *sophistication* implies a sense of style exhibited through the lines of a composition and the relationships of its parts, usually with some degree of complexity. For example, acute or complex angles can generate this sense. So, too, can interesting material combinations or, as seen here, an unusual color scheme.

Decorative elements can also add sophistication and even in quite simple settings should not be neglected, though care must be taken not to overdo the embellishment of an otherwise simple design.

Variations on a theme

More verdure, especially in juxtaposition to the chipped and decked areas, would be an asset. For example, vines growing on the fence would soften it, as would a water feature display.

Where this style can be used

For an inexpensive solution to a children's play area, or for any small space requiring virtually no maintenance, this approach is excellent.

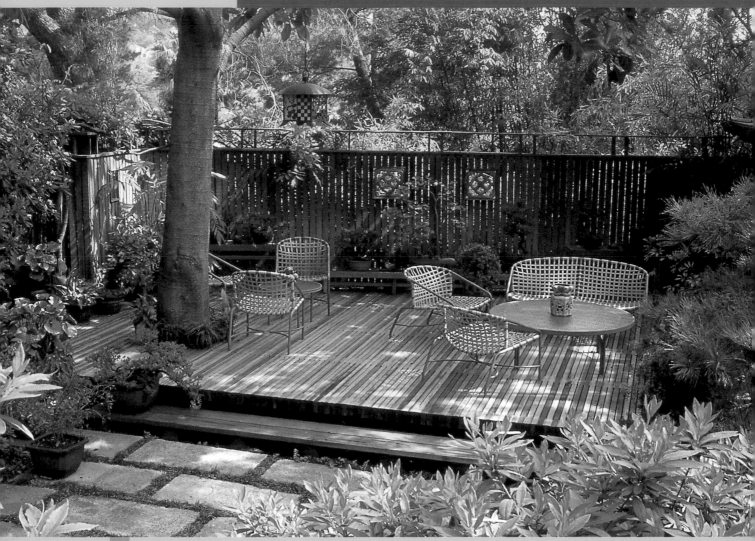

 Seen from the paved area, the deck offers an inviting place in the shade. Notice the continuity between the deck and the fence.

A serene garden in
wood, pavers, and plants

Too much of anything is, of course, too much. The discomfort we feel in any setting where concrete or other hard surfaces predominate and no natural lines or materials are to be found comes not from these things in themselves but from the lack of natural, organic, comfortable elements to balance them. Contrarily, anyone who has visited tropical or subtropical regions can testify to the discomfort felt when surrounded by or even simply beholding a superabundance of foliage and flower without any structure. Such gardens call out for the relief of hard surfaces, sculpture, or even functional components of a durable material—for structure—not because plants are unpleasant but because we naturally find beauty in balance.

The look

Here is an elegant solution for a lawnless garden: a fine wood deck rising above stone pavers with herb joints, surrounded by lush plantings. A tree grows through the deck, backed by a fence in the same style. The tree provides a shady haven while the paved area offers abundant sun. Everything here works together agreeably, with delicate details contained within a boldly set-out paradigm.

A garden of perfect balance—between sunny paving and shady deck, rectangular surfacing and abundant foliage.

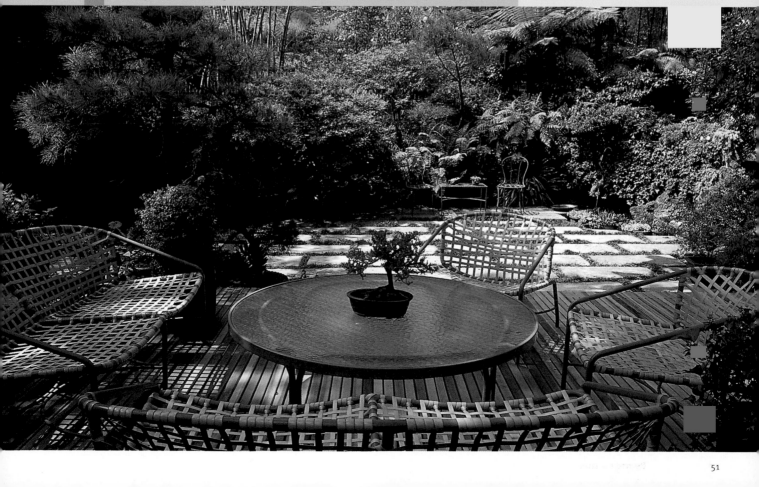

What works and why

The clean lines of the fence, wood deck, and rectangular pavers balance beautifully with the wonderfully lush planting on the borders, as does the decked area in the shade balance with the paved area in the sun. None of this garden's elements—the rectilinear shape and the volume of plants, the shady deck and the sunny patio, would have been nearly so pleasing without its counterpoint.

In detail, the foliage is carried ever so slightly into the paved surfaces through the herb joints and deck plantings; likewise, the structural elements are brought into the planting area by means of the table and chairs on the far side and the rock and sculpture to the right. These integrating elements contribute to the unification of the garden.

Fine subtleties are found in this garden. Notice how the Japanese-looking pine to the right of the garden is echoed in the bonsai on the tabletop. Similarly, a set of chairs and table in the rear of the garden repeats a larger set found on the deck. The fence behind the decking and the web weave of the furniture likewise harmonize, and the pots, hanging lantern, and ornaments are all of a kind and help unify the garden.

Variations on a theme

The simplicity, balance, and right amount of ornament in this garden seem perfect and need no modification. For a slightly different look, another kind of stone or concrete could be used for the pavers, but the lines should remain rectangular. Likewise, a different kind of wood could be used, perhaps with equal effect—but again, the rectilinear aspect of the layout is crucial to the success of this garden. Changes could be worked into the planting scheme, which is quite eclectic yet effective, and a different sort of ground cover, say ajuga or violets, could go between the pavers.

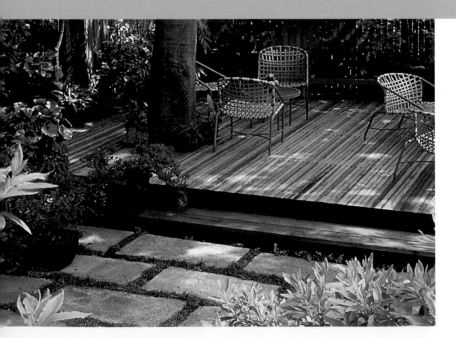

Where this style can be used

This garden design is particularly suited to a country setting, to a suburban setting not dominated by large homes, or to an urban environment with low-profile structures, as part of its success derives from the depth of the background plantings. The same concept of a lush area balanced with a linear arrangement could even be employed on a rooftop where space permits two distinct but joined rooms.

Alternative mixed-media designs

Tool shed
Stone patio
Small pond
Bench
Pebble bed
Pebble path Stone inset

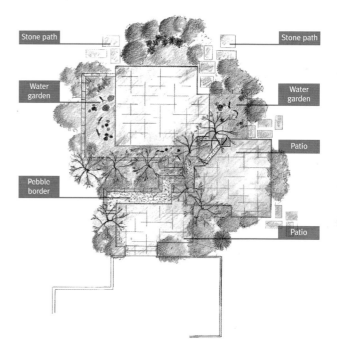

Stone path Stone path
Water garden Water garden
Patio
Pebble border
Patio

↑ A winding gravel path with stone insets leads to a stone patio and small pool. Planting is staggered along both sides of the walkway so that the visitor discovers the garden only gradually. As he comes around the end of the small pond he steps into the patio area. Small ornamental trees, shrubs, and perennials overhang and embrace the living areas. A tool shed is slightly hidden in the rear of the garden.

↑ Three stone patios are joined by narrow passageways overhung with trees and shrubs. The first is bordered by a river-pebble bed, the second by a pebble bed and a contemporary style ground-level pond, and the third by two ponds and gardens. Stone walkways lead from the second and third patios to other areas of the garden. All is enclosed by lush plantings.

Pebbled gardens

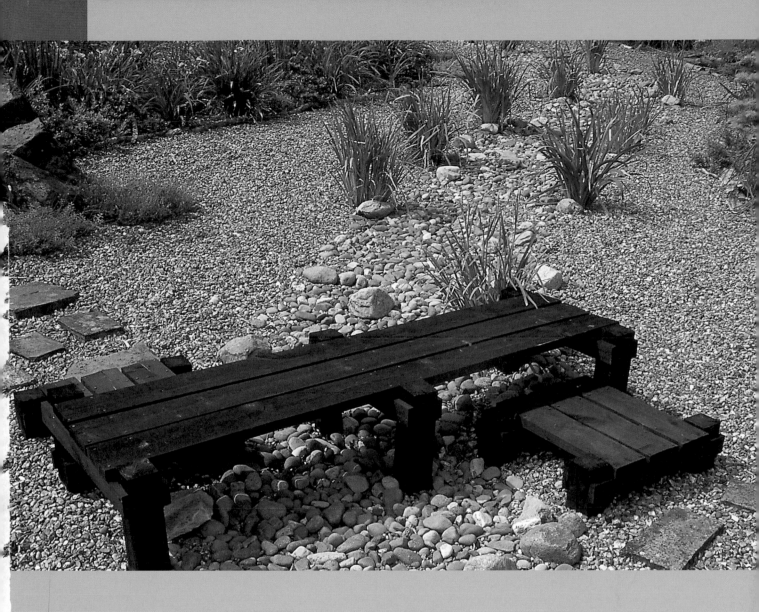

Whether you want an informal or a formal look—easily altered or permanent and durable—pebbles are a wonderful, low-maintenance alternative to grass. Available in a wide range of sizes and colors, you can use a given pebble type alone, in combination with pebbles of different sizes or colors, or combined with other materials. Laid loose, pebbles can create a pleasantly informal patio or a highly stylized Asian garden, or simulate a natural stream bed. Set in mortar, pebbles can be used to create a lively, whimsical patio garden or evoke an Old-World courtyard formality with a warmly sophisticated mood. The options are endless.

Here, we examine both formal and informal arrangements where the predominant surface is pebbles, used alone or in combination with other elements to create wonderful alternatives to lawn.

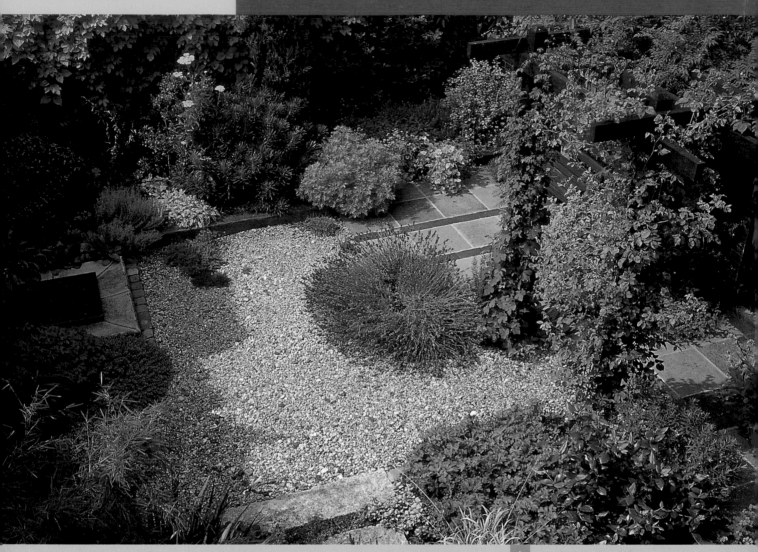

A garden haven in pebbles and plants.

A
stony
oasis

The look

This rectangular plot has a water feature at one end and flagging at the other. It is paved in loose pebbles of mixed hues and varying sizes from 1/4" to 2" (1 cm to 5 cm) long, surrounded and accented by verdant plantings.

What works and why

The overall effect of this garden is surprisingly and delightfully refreshing. Though pebbles are a dry element often associated with hot environments, the pebbled bed here seems as inviting as a pool of water. How can we explain this?

Pebbles take on the values of their surroundings. In a stream, for example, pebbles look cool; on a sunny, dry bed they look (and in fact are) quite warm. Here, owing to the cast of shadow and especially to the verdant surroundings, the entire environment takes on a cool, refreshing quality in which the pebbled bed participates. Note how the light tones of the pebbles are picked up and reflected back in the pale green and yellow-greens of the plants. This ties the pebbles to the plantings and emphasizes their interaction. Likewise with the flower colors—the lavender, rose, and yellow of the blossoms are all contained within the pebble bed. Our eye, quite unconsciously, travels back and forth between the harmonizing color values of the plants and the paving, so we see not a pebble bed surrounded by plants but a garden in which plants and pebbles

are bound together through similarity of color values. The effect is perfect.

Also contributing to the success of this garden are the harmonies within the geometrical hardscape of the interior, the harmonies within the rounded forms of the plantings, and the contrast between these two. The water garden at one end reflects the flagstone paving at the other; they and the pebble bed are contained within an enclosing rectangle. The rounded lavender in the center and the plantings along the sides contrast pleasantly with the interior. This contrast of organic, feminine lines embracing masculine, geometric forms presents a complete and satisfying picture.

In a pebble garden, it is often a good idea to create an adjacent surface of a more fixed nature. Pebbles laid loose will move through use, and there are some uses to which they are not appropriate, such as active sports or dancing. A nearby area, as shown here, or an area contained within the pebble bed paved in a flat, even material can prove a serviceable companion to the pebble garden.

Nothing in a garden exists alone

A garden is by nature a world of relationships—the relationship of the plants to the soil and air and light and to the beds or containers that hold them, the planting areas to the paved areas, individual plants or materials to one another. This is what a garden is—a world of interacting and interactive relationships. As such it offers the opportunity to experiment, to discover, and to create exciting, soothing, dramatic, subtle arrangements—all kinds of beautiful, enjoyable connections. For this reason, it is important to consider how elements will combine. Nothing in a garden exists alone. Everything in it affects and is affected by its surroundings, so it behooves us to consider well each element we include in our garden.

Variations on a theme

This garden suggests few potential modifications, as it is simple and essentially perfect within the paradigm it represents. One change might be to move the lavender plant to one side and limit the entry to the pebble garden to one side or the other or the middle, rather than from both sides. The flagstone paving could be of a different material or a different kind of stone. The water garden could be replaced with sculpture or some other structural element.

Where this style can be used

As the surrounding verdure is essential to the success of this garden, a place where high walls can be planted with vines or high hedges grown is essential. Also, the space must be large enough to accommodate such lushness while leaving room for the pebble garden, the water garden, and the adjoining paving.

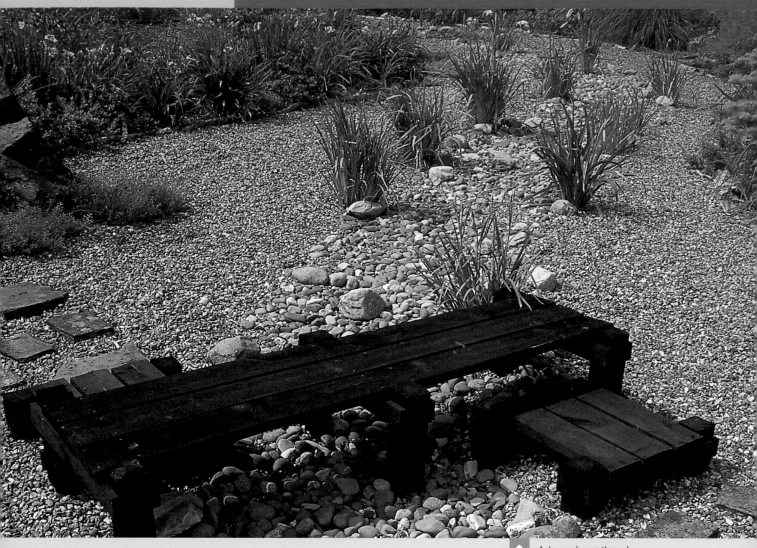

A dry creek runs through
a pebble beach.

A
dry creek
bed

Accents accent

Accents, a device used in nearly every form of visual arts, do more than provide points of interest. When well done, they throw the surrounding in which they are found into sharp focus—they accent their surroundings. This is often achieved through the principle of contrast. A square makes a circle seem rounder, red makes green greener. A dark line cutting diagonally through a light plane bring out every detail of that plane, making it not only clearly seen but viscerally felt.

The look

A beach effect is formed with fine, washed, yellowish pebbles through which runs a dry creek bed in larger, washed, gray pebbles. Plants are randomly distributed throughout, with a single species accenting the length of the creek bed. A bridge crosses the creek; steps lead to an informal path on either side.

What works and why

This is a simple design, yet much more satisfying than an expanse of lawn would have been and requiring considerably less maintenance as well. We all enjoy the clean, uniform surface of a pebbled beach. Add to that a stream of smooth, river-rounded pebbles of a contrasting size and color and a few plants drifted about in natural groupings, and you have the formula for a charming landscape requiring very little care.

The dark wood bridge cuts crosswise through the stream, forming a dramatic contrast both in color and by the diagonal line along which it is laid. This is a definite and intentional disharmony, or sharp contrast, that brings vitality to the otherwise placid scene and serves as counterpoint to tranquility. It arrests the eye, which is then called back to wander over the expanse of pebbles and bright bursts of blossom and foliage.

Variations on a theme

There are many ways to alter this design without abandoning it. The kinds of pebbles used, the line of the stream, the presence and style of the bridge, its placement, the stepping stones that lead to it, the plant selections and how they are grouped—all these lend themselves to variation. A few large stones or small river boulders could be strewn randomly along the length of the stream bed. In fact, this motif could be expressed a thousand different ways, each of equal interest and beauty.

Where this style can be used

Though this garden is clearly large, the same motif will fit in a much smaller space simply by reducing the scale, which makes it workable in rural, suburban, and urban settings. This site receives full sun, but the motif can work well in dappled and possibly even in deep shade.

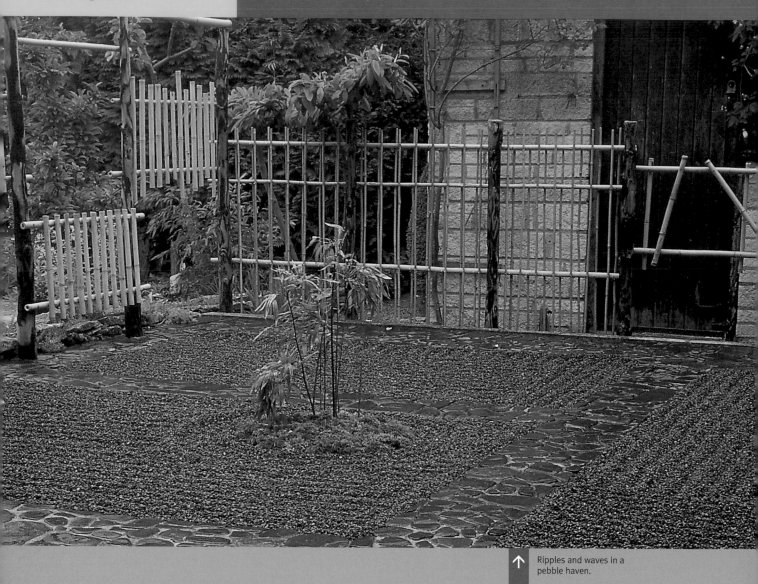

Ripples and waves in a
pebble haven.

Oriental
simplicity

The look

This is a classic example of an oriental garden, meant to provide visual pleasure and personal satisfaction. Cobbles in mortar serve both as pathways allowing access to and through the entire garden and to define individual areas. Bamboo fencing screens unwanted views and contains the landscape without creating too great a sense of enclosure.

What works and why

Consider the difference between this landscape and a lawn with a specimen plant or two occupying the same area. Whereas a lawn may invite use, it frequently goes unused and, as ubiquitous as lawns are, pretty much unnoticed too. Not so this landscape. Created with enormous intention and attention, it invites perusal and contemplation and rewards the viewer with the satisfaction of its clean, flowing simplicity.

The plantings take on significance as isolated islands, their influence rippling outward through the garden. Plants in oriental gardens often seem to express deep meaning—a microcosmic representation of something that exists on a larger scale.

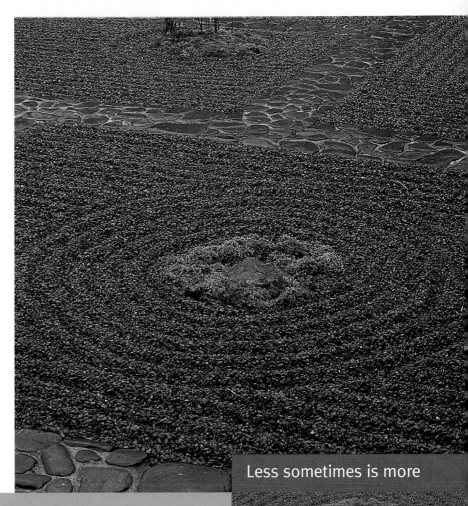

Less sometimes is more

Variations on a theme

A garden such as this allows for endless permutations. A few larger stones can be placed within the raked pebbles, the pebbles can be raked differently, the pathways can be individual stepping stones. A traditional Japanese water feature might be added, the bamboo screening might be differently done, and so on.

Where this style can be used

This sort of garden is best and usually seen in an enclosed area. Size is not important, as the same theme can be reproduced even in a dish garden. It is not a garden for use, however. Rather, it is meant to be seen and contemplated, and the act of caring for it is intended to be a therapy for the soul.

Certainly, impressive effects can be achieved by massing plants into gorgeous groupings but, when carefully selected and placed, a single plant can do as much as or more than many. This is especially true when the plant is set against a highly contrasting surrounding or backdrop. On a lawn, where the so-called specimen plant is often placed, the specimen tends to get lost, visually blending into its surroundings. When a single plant is placed in a nonvegetative field, such as a pebble garden, its individual characteristics are more readily appreciated. Similarly, when a backdrop is created with, for example, a stand of spruce, the distinctive foliage and blossom of a shrub—mountain laurel or mahonia, for example, can be more thoroughly enjoyed against the consistent, contrasting foliage of the spruce.

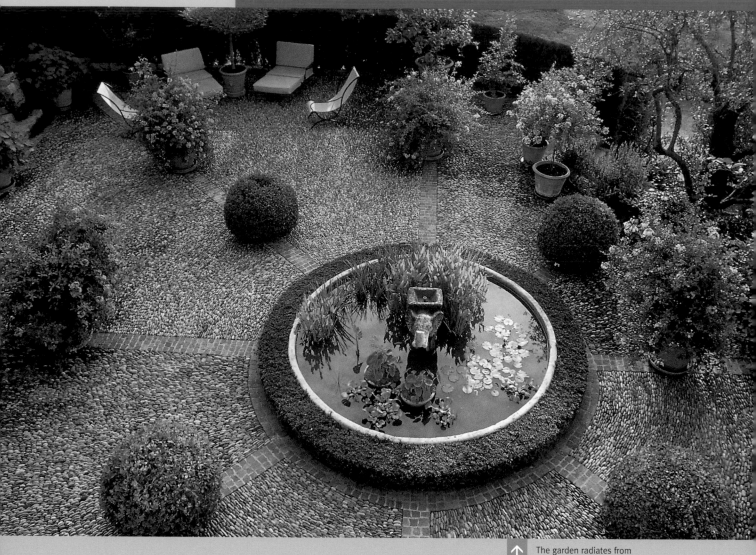

↑ The garden radiates from the central pool.

An elegant garden in the round

The look

A large court is paved in pebbles with a central, circular pool edged in boxwood. Plants and planted pots surround the pool, radiating outward, as do the cobbled, pie-shaped segments of paving, the pebbles of which alternate from wedge to wedge in the direction of their placement. Abundant foliage, flowering trees and shrubs, and comfortable furniture create an inviting environment, both elegant and relaxed.

What works and why

Though serene and inviting, this is also a lively scene, filled with motion—a consequence of the way in which everything seems to radiate from the central pool and of the alternating directional placement of the pebbles. The garden has a formal aspect, induced by the geometry of forms, yet the overall feel is relaxed and casual; in fact, these two opposing styles are wonderfully balanced. The clipped boxwood and planted pots that surround the pool contribute to the garden's formality, but the scheme is not strict—note the random planting groups that break out of the circular motif.

The pool embodies this blended principle of formality and informality quite well. It is clearly formal, with an equally formal fountain in the center; it is edged in clipped boxwood, but the interior planting appears casual. Moving outward from the pool is boxwood formally clipped into globes balanced by planters sprawling with informal flowering shrubs. Comfortable chairs are placed beneath the shading branches of an overhanging tree, creating a casual seating area, while nearby, a formal staircase leads up to another portion of the landscape. The pebbles themselves are an informal material, but they are laid with obvious attention and care. The result of this melding of formality and informality is a garden at once elegant and playful.

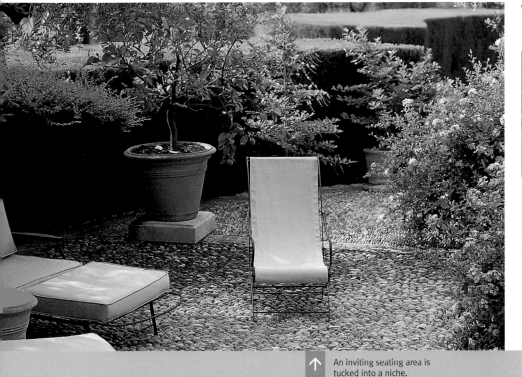

An inviting seating area is tucked into a niche.

Blending styles

There are formal gardens, natural gardens, Arts and Crafts gardens, Mediterranean gardens, contemporary gardens, Dutch gardens—all kinds of garden styles—but a garden need not be any one of these. It is possible to successfully and effectively blend elements taken from different styles. A haphazard approach won't work, but a design incorporating disparate elements one happens to enjoy can succeed if conceived as a whole. For example, a generally formal layout with informal elements included—symmetrically rectangular planting beds with informal plants, say—can make a most enjoyable setting. A natural garden with some formal component, such as a sculpture, can likewise be satisfying. Qualities from the style of Arts and Crafts incorporated into a Spanish Mediterranean style can result in a garden that is both elegant and casual. All depends on taste and the ability to generate a coherent balance between the contrasts.

Variations on a theme

The surrounding hedge creates a sense of enclosure, confinement, and security. Were the garden instead opened to the surrounding countryside, it would lose some of its intensity but would have a greater sense of breadth and breath from a free exchange with the surrounding environment.

Where this style can be used

Though this would seem to be a landscape best suited for a country estate, the same garden, reduced in scale, could be created in many urban or suburban settings. All that is necessary is to scale everything down while maintaining the relative proportions of the various components.

A gold and green garden with a pebble beach.

Gold and Green

The look

This is a portion of a garden in which lawn was eschewed for far less demanding pebbles and a shrub and perennial border. The result is straightforward but thoroughly enjoyable and serviceable.

What works and why

The undulant line of the pebbles' edge gives a beachlike effect, lapped by the frothy blossoms of Alchemilla mollis. The pebbles chosen for this garden are small and delicate, harmonizing nicely with the tiny blossoms and leaves of the immediate border. The bright yellow of the edging, trimmed in fresh green, is repeated throughout the garden, helping unify it. In the foreground are geranium, fennel, astrantia, and eryngium with the ornamental grass Carex elata 'Aurea,' or golden sedge. Golden privet and aucuba add solidity and mass and serve as a backdrop to these delicate displays while carrying on the theme of green and gold. The garden fairly shimmers with color, but a great portion of this comes from foliage alone; little flower color is needed. A few well-chosen flecks of lavender, purple, and white add all the variety of color needed.

Particularly interesting and effective here are the pyramidal forms of the clipped Euonymus. This is a loose, free-form garden; in this context, these plinthlike shrubs add structure and anchor the garden at each end while framing the bench.

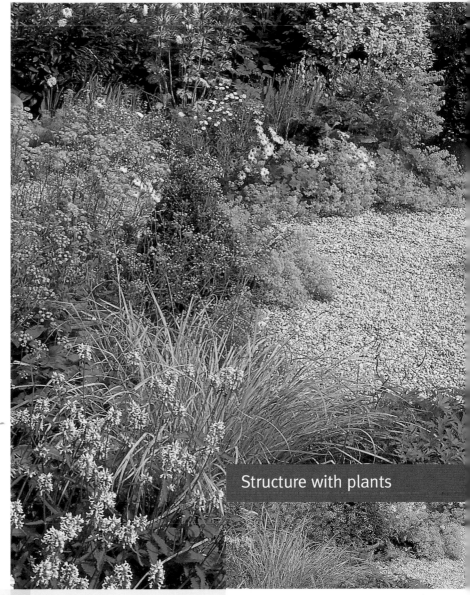

Structure with plants

↑ White, lavender, and purple bring bright splashes to the garden.

Variations on a theme

This green and gold garden relies heavily on foliage color for effect, but a green and white theme would also work well here, still drawing on plants with variegated foliage. If plants with bolder foliage were wanted, a larger-sized pebble might be appropriate. Of course, the plant choices are endless.

Where this style can be used

This would make a wonderful front yard garden in any suburban neighborhood—a delightfully refreshing alternative to the ubiquitous lawn. It also makes a pleasant rear yard or courtyard garden where light is sufficient.

Every garden needs structure. The more abundantly planted, the more foliage and flowers a garden contains, the greater is the need for solidity and form. In a formless garden, plants can fill this need. Topiary—plants clipped into definite shapes—are often employed for this purpose, such as around an interior planting of rambling roses or amid plantings of other less defined forms.

Many a perennial border would be well served if at intervals along its length a plant clipped into a spire or well-defined mound or a piece of sculpture balanced the sprawling foliage and blossoms that generally characterize such gardens.

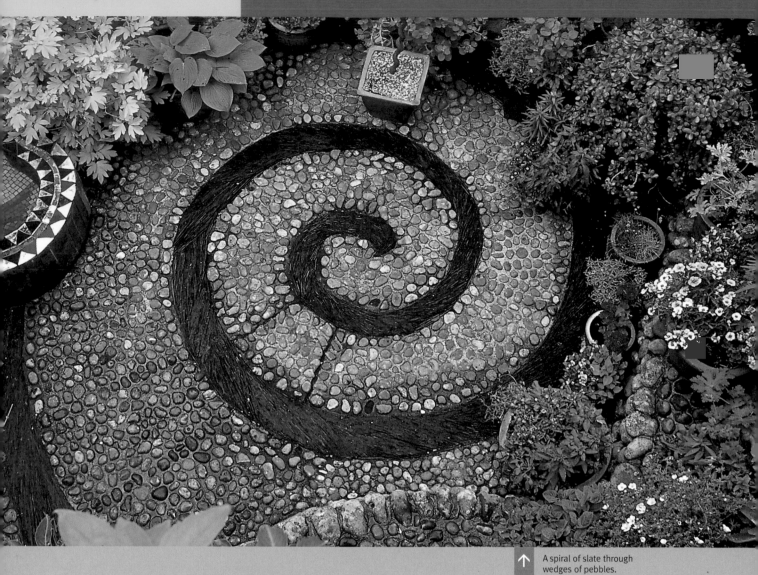

A spiral of slate through
wedges of pebbles.

A
radiant patio
in
cobbles
and slate

The look

A small garden space is given a distinctive and whimsical look through the use of large pebbles, set in mortar, that radiate from the center and contrast with the slate spiral swirling through them. A lush container garden exhibiting numerous perennials, annuals, and shrubs surrounds the paved area.

What works and why

The distinctive design of this garden patio strikes us at once with its bold whimsicality. It is bright, cheerful, flamboyant, and not quite like anything seen before. Though clearly durable and solid, the paving is filled with motion, a consequence of the spiral, the pie-shaped sections delineated by the darker pebbles, by the curving tiered borders edged in larger cobbles, and by the placement of the individual pebbles themselves, which are laid with respect to both shape and color.

Curving tiers of cobbles and pebbles permit planted pots to ascend through several elevations, adding dimensionality.

The cobbled tiers are a notable asset to this garden. They carry the curvy pebble theme upward in a pleasantly ornamental fashion, permitting the placement of planted pots that form an informal wall of flower and foliage, receding as it ascends. Although the patio is an ornament in itself, the tiers of container plants surrounding it greatly enrich and soften the scene. The setting is perfect for showcasing the ornamental pots and other decorative elements that add the final details to this delightfully attractive vignette. Seen from the house, the patio is an inviting sanctuary.

Seen from the house, the garden makes an inviting appeal to enjoy its whimsical quality.

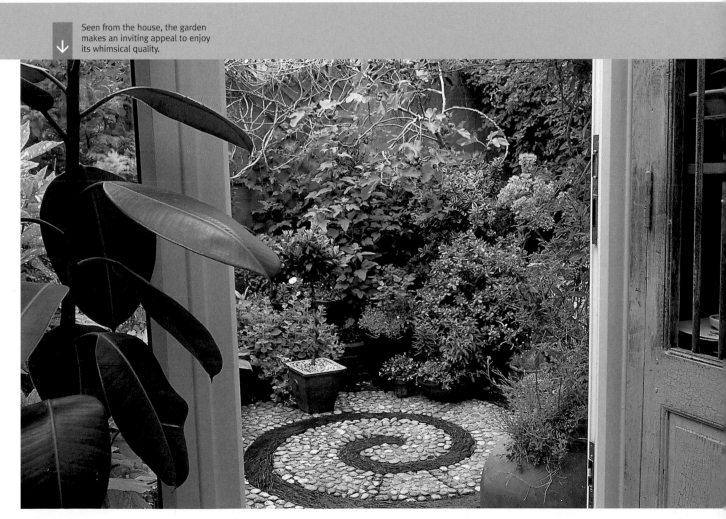

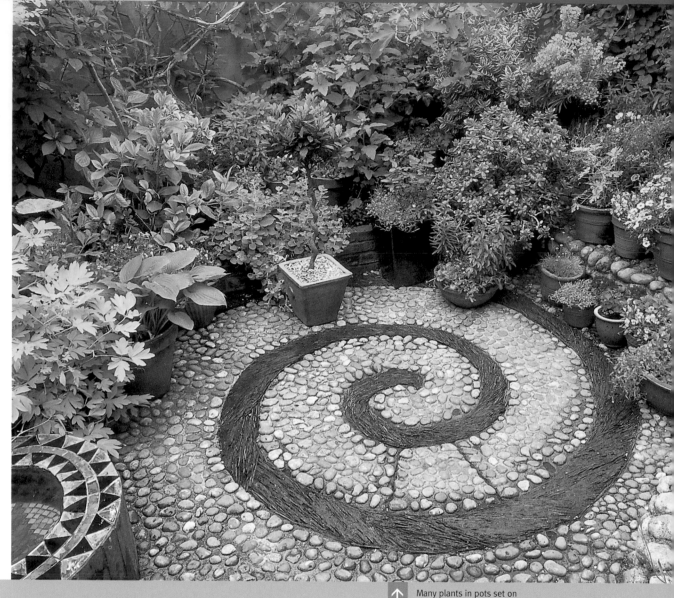

↑ Many plants in pots set on raised tiers balance and highlight the mosaic patio.

Variations on a theme

This design is not easily altered without losing integrity, as each element so thoroughly belongs to and arises out of the whole. Nevertheless, if we consider the design simply a patio of pebbles with borders of shelves in ascending elevations, then it could be rendered in many patterns and shapes with any variety of ornament or water feature.

Where this style can be used

This is a design for a small, enclosed area in a temperate climate, as all the plants are in containers. It is easily accessed from the house and is intended as a highly ornamental extension of the home—a garden room or solarium—so it should be located adjacent to an entry and easily visible from within.

Alternative pebbled garden designs

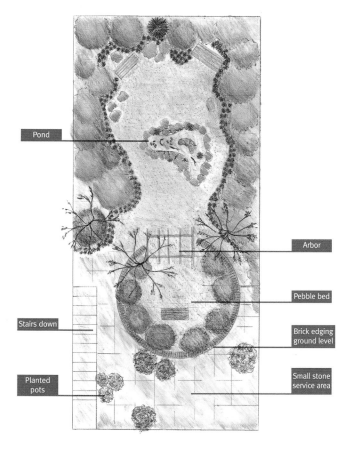

Pond

Arbor

Pebble bed

Stairs down

Brick edging
ground level

Planted
pots

Small stone
service area

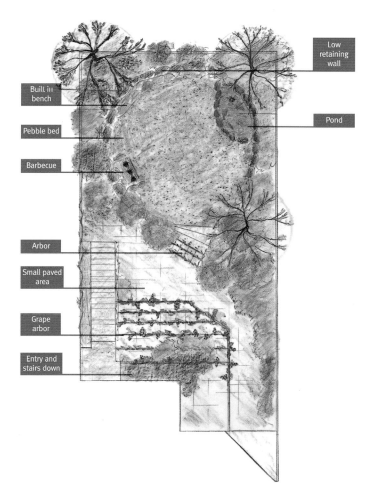

Low
retaining
wall

Built in
bench

Pond

Pebble bed

Barbecue

Arbor

Small paved
area

Grape
arbor

Entry and
stairs down

↑ A semi circular brick edging encloses a formal pebble bed planted in broadleaf evergreen shrubs and looks out upon an informal pebble bed with a pond, bordered by flowering shrubs and perennials.

↑ A paved area partially covered by a grape arbor leads down several steps, through another arbor to a pebble bed that contains a barbecue, a small pool, and a stone bench built into the raised retaining wall. Trees, shrubs, vines, and perennials enclose the pebble garden.

Bricked gardens

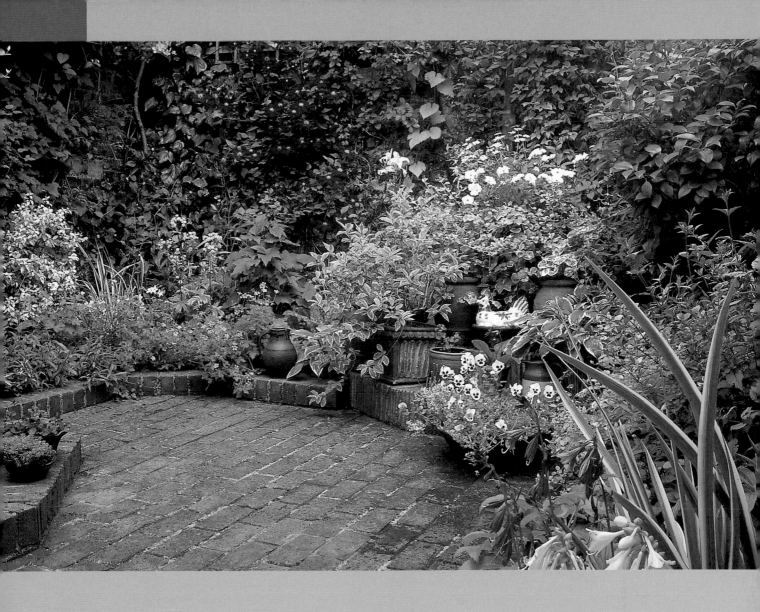

Brick is a classically elegant material with a warm feel. It is available in many colors and sizes and can be set in an endless variety of patterns. It is not often suitable for a front yard but makes a superior interior courtyard surface or back patio garden. Brick combines extremely well with plants and looks handsome near water and most natural building materials. It is fairly easy to install, inexpensive, and durable, and its clean, attractive surfaces are easily maintained.

Because of its regular, rectangular shape, brick is usually laid in a symmetrical design, so although it is intrinsically somewhat informal, being nothing more than baked, unglazed clay, it lends itself to formal constructions. However, an entire area can be paved in brick with planted containers placed about to make a thoroughly enjoyable, informal patio garden. This is often done where space is limited. Planters can also be built in as part of the patio, yielding a more formal effect. Here, we examine a variety of brick gardens of formal and informal design.

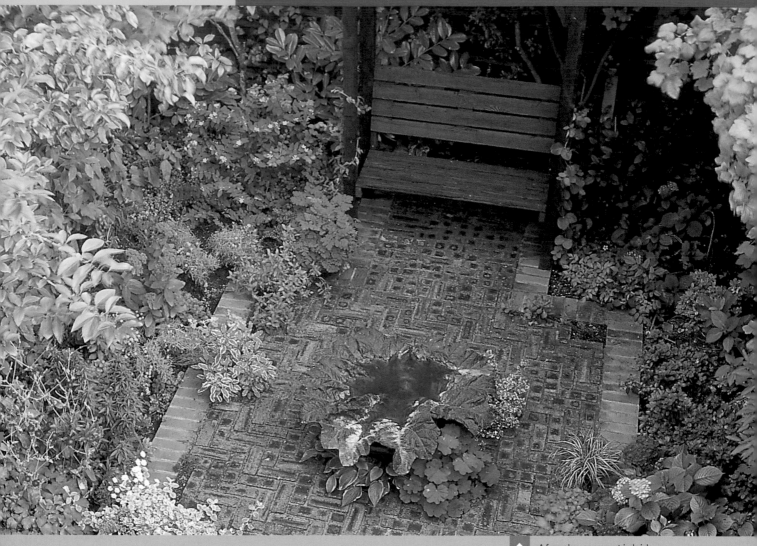

A formal arrangement in brick with informal plantings projects an enjoyable balance of opposites.

A clinker patio with leaf pool

The look

Clinker brick is brick that was burned in the firing. They are characterized by a dark, black to bluish char mark, are often bulged or split, and have a metallic ring when struck, the result of the fusing of the molecules by heat, called *vitrification*. Though originally an accidental consequence of bricks being too near a heat source, the aesthetic value of clinkers' richness and variability began to be recognized. Requests for them spurred their deliberate production, although they are not widely available today. They often appear in combination with normal, unburnt brick, and in this manner they have the most pleasing look.

The surface is composed mostly of clinkers peppered with a few common red bricks, and it is edged in common red brick as well. At one end is a pergola for sitting and enjoying the garden; the other end leads to a terra-cotta tile entry walk.

What works and why

The layout is pleasingly symmetrical, conveying a sense of dignity and order, but the formality of the design is softened by the casual, abundant planting that balances between these two styles. In like manner, the elegant leaf pool in the exact center is a formal element modified in effect by its shape and the informal plantings beneath.

The common red brick edging and the terra-cotta tiles frame the clinker patio. The pergola, with its bench, serves both as a visual terminus to the garden and as a destination for the visitor—a fine vantage point from which to view and enjoy the garden. Set off the end of the patio, it serves its purpose without spoiling the symmetry.

Blending formality and informality

Many people have an aversion to formal gardens. They are afraid of the control or rigidity they imagine a formal arrangement to possess and tend to think of formality as an all-or-nothing approach. However, many gardens would benefit from a formal component, both as a valid and pleasing element in itself and as a counterpoint to the informality. One area may be laid out in a formal pattern that adjoins an informal area, or a formal arrangement may be modified with informal components. Combined, the two styles can work together to great effect, satisfying our need for order, our appreciation of beautiful proportion, and our love of nature.

Variations on a theme

The brick could have been laid in a different pattern, and the plantings could be infinitely varied. The leaf pool, though beautiful, might have been a little smaller. As for the pergola, a simple bench without a roof structure would also have worked. The clinker bricks are a significant feature of this design, however, and it would lose considerably were only red brick used instead.

Where this style can be used

This design is best suited to a backyard or courtyard garden rather than a front garden. It lends itself particularly to a small garden in an urban or semiurban setting.

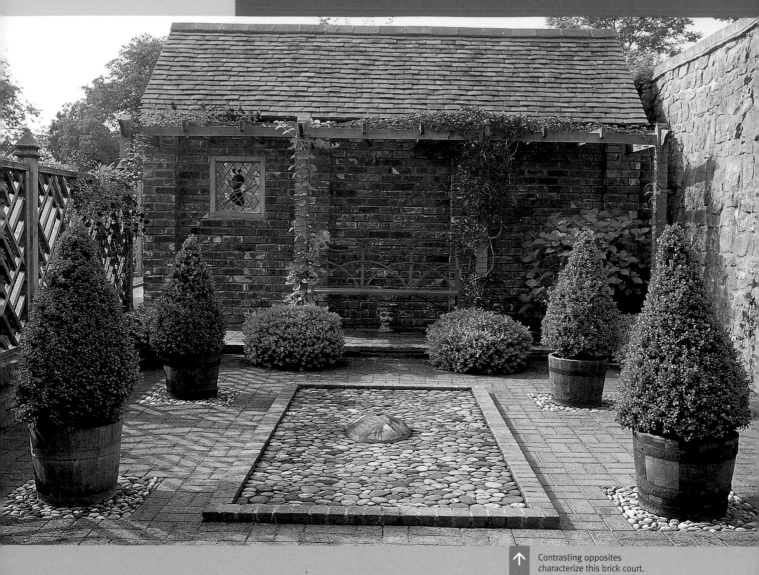

Contrasting opposites
characterize this brick court.

A
court with a
shallow pool

The look

This classic design is characterized by geometric symmetry—with a touch of the rustic. A narrow rectangular pool centered within brick paving and flanked by topiary set on pebble-filled insets, occupies the place of prominence. To the center rear, a bench, evenly placed between two vine-clad columns, commands the view up the long axis. An open woodwork fence on one side, a stone wall on the other, a brick outbuilding, and the home form the boundaries of this garden.

What works and why

This garden is meant to be seen and enjoyed from the perimeter. Casual strolling rather than active use is invited. The brick forms a pleasant and structurally sound platform that sets off the few ornamental elements around it: the cobble-filled pool, the topiary, and the pebble-filled insets on which are placed planted wine barrels. Though the garden is formal, its friendly aspect is attributable to the brick—a warm, familiar material—to the pebbles in and out of the pool, and to the wine cask planters. Had the planters been made of stone or cast stone or given a square or rectangular form, they would have emphasized the formality of the garden, but as half wine barrels they soften and relax, conveying a country quality within the symmetrical arrangement. The garden contains surprisingly few elements and, though simple, it seems complete. This is due to the balance of opposites—spirelike topiary in round barrels; brick against water; rounded pebbles set in square brick; round, low-spreading shrubs and upright, pointed shrubs; and the green of the shrubbery against the red of the brick. Though we are not consciously aware of it, it is this interplay of opposites, of contrasts, that makes this simple arrangement so satisfying.

Variations on a theme

The pool could have been made smaller, in which case the surrounding area would have taken on more significance and been rendered more usable. If enhancement of the formality is desired, the planters could be made of a more elegant material and be rectangular in shape. The pool could have a different inner surface and be edged in another material, perhaps a light sandstone or even a light concrete edging, which would pick up the light stone in the insets.

Where this style can be used

Although this garden is enclosed, it need not be. The same layout given a border of plants rather than walls or fences would be equally effective and could be placed nearly anywhere, including a front or rear yard in nearly any environment in which a formal arrangement is desired. It is important, however, that there be an enclosing element, as the garden needs a frame to be complete.

An attractive patio surrounded by an abundance of beautiful plants.

Tiered patio and planters

The look

A brick patio laid in a running bond was built with several tiers rising above it, one of which is an angular dais with table and chairs. Planted containers occupy other tiers, which are stepped back as they ascend, thus serving as both retaining walls and horizontal platforms or shelves. A rich abundance of plants gives meaning and purpose to the whole.

What works and why

Unlike the previous example, this garden was designed to be experienced from within. The brick paving provides a comfortable surface requiring little care. It serves as a companionable foreground to the foliage and flowers, with which it both contrasts and harmonizes.

The tiers are an important design element in this garden, permitting the planting to extend upward. This vertical dimension is particularly desirable in a space as small as this. The brick ledges are also the perfect home for planted pots, which amplify the dimensionality of the tiers through structure, texture, and detail.

A subtle but significant detail here is the angled corners and the matching angular dais. Had this been an ordinary rectangle, the space would not be as visually interesting, or as pleasing. The precise and corresponding angles give the space a degree of sophistication otherwise lacking, and they prevent the garden from feeling boxy.

↑ Stepped tiers provide ledges for planted pots.

The flexible third dimension

In a garden, the third dimension is often not given the attention it deserves, even though it is the only dimension that can be extended to the limits of our perception and beyond. Plantings raised above eye level give the impression of going on endlessly. This is especially true if their upward termination is made uneven and imprecise by varying the heights of plants. We feel enclosed by foliage and flowers and simply stop looking up to the garden's vertical limits.

Variations on a theme

This garden is so thoroughly imbued with a sense of place it is difficult to change anything without adversely affecting the whole. Certainly, however, the same motif could be used as effectively in another climate with a different planting scheme.

Where this style can be used

This makes a superb urban garden suitable to many thousands of city backyards. The same style could be adapted to portions of suburban landscapes as well.

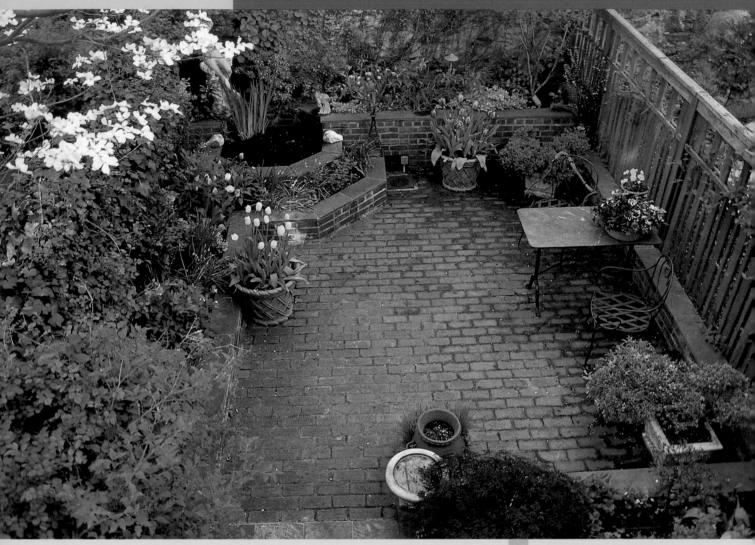

↑ The fountain pool is a natural
outgrowth of the total design.

Formal
elegance

↑ The tall, arching wall in the rear sets the tone for the entire landscape.

The look

A large brick wall rises up at the far edge of an expanse of brick paving bordered on four sides with low brick walls capped in stone. On the left, front and rear, these walls also serve as retaining walls for planting beds. In the far left corner an angular raised pool with fountain rises above the angular planter and is adorned with a sculpture. Various planted pots and garden furniture are distributed randomly about.

What works and why

Though the layout is asymmetrical, there is a formal elegance and beauty to this landscape that arises from several factors, not least of which is proportion. The rear wall could completely dominate the entire garden in an oppressive manner, yet it does not. This is owing to its curved top, its pierced arches, and that its tall vertical surface is perfectly balanced by the long horizontal paving of the same material.

The wall sets the stage for the rest of the garden, which would appear far more ordinary without it. Its elegance and grandeur to the whole and through balance and harmony, bring out the combined charm of the brick and stone patio, the multilevel brick and stone planters, the pentagonal water garden, the planters, and the sculptures.

Built across this and the adjoining property, the wall is off-center of the garden; however, it does not appear so. Why is this?

Several factors are involved. The garden is asymmetrical along both axes—it does not attempt to balance evenly with the wall. If it did, the entire garden would be confusing and quite unsatisfying. While the wall is weighted to the right, the garden is weighted to the left, thus bringing equilibrium to the asymmetrical arrangement.

Finally, a clever device was employed. The metal ship, placed just above eye level, is the point to which the eye is drawn. This becomes the visual center of the wall, particularly from within the garden. Thus all seems balanced along the long primary axis.

The cross-axis is balanced well by the planter in the corner opposite the fountain, by the stone-topped wall on the right, and by the planted pots and the table. In all, this garden is a marvelous achievement of equilibrium within an asymmetrical design.

The design for this formal fountain arose, as it should, from the overall landscape design. It is a natural outgrowth of everything else that is happening in the garden, from the tall rear wall through the raised beds. All is of a piece. The fountain shares the same rectangular layout as, and is proportional to, all the other elements—neither too large or small nor too high or low.

The fountain brings a wonderful elegance to its corner of the garden. Further, it serves as a transitional element from the oppressively tall rear wall through the two levels of planters down to the patio, smoothing the leap between elevations. It also provides the beauty of water on display in a formal setting and is the perfect foreground and backdrop to the lovely sculptures.

Formality and symmetry

It is generally thought that a formal design implies symmetry and, often enough, a formal layout is symmetrical. Yet an asymmetrical arrangement can also convey the sense of formality if it is balanced, well proportioned, and built with formal or classical materials, as this garden demonstrates.

Variations on a theme

Though the bluestone coping on the walls works well, other stone of an equally contrasting material—a light sandstone, for example—would also work. The fence on the right could, in like manner, be iron rather than wood, and any variety of plants could substitute for those chosen, though the dogwood on the left is too perfect to be replaced.

Where this style can be used

This is strictly an urban garden; it would not transplant well to a suburban or rural setting. The design requires, however, sufficient room in which to construct the towering wall.

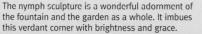

The nymph sculpture is a wonderful adornment of the fountain and the garden as a whole. It imbues this verdant corner with brightness and grace.

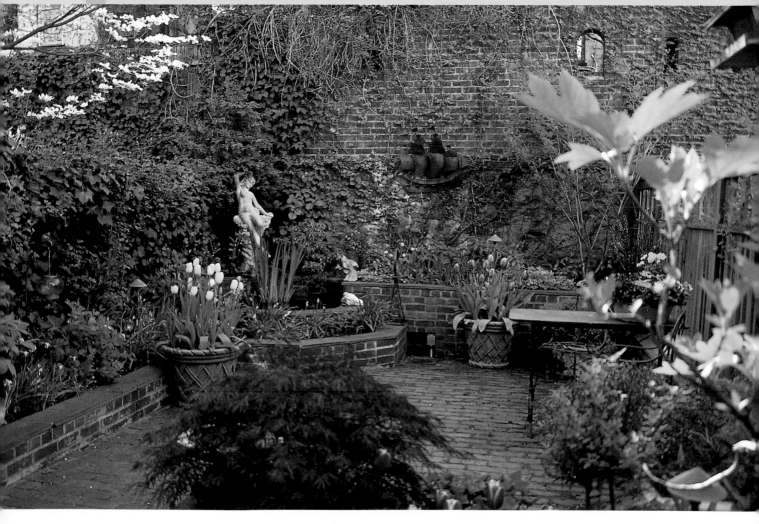

A basketweave patio and a natural stream create an attractive dichotomy.

A Patio and stream combo

The look

Before this brick patio was installed, this space was occupied by a lawn, with walkways up the sides and rear. For years after the patio was installed, it provided living space and enjoyment enough, but the owners began to feel that more was possible. They decided to add a stream that originates in a pool in the upper left, winds through the patio, and terminates in a small pool in the lower right, from which the water recirculates, unseen, back to the top. The stream is planted with a variety of perennials and shrubs.

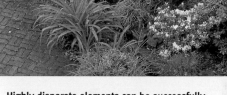

Wedding differences

Highly disparate elements can be successfully combined, often through the use of an intermediary element to which both relate. Normally, a stream would not flow through a brick patio, but planting and brick go together and so do planting and streams. By bordering the stream with plants where it meets the brick, the two disparate elements are integrated and wed into a single composition.

What works and why

This is an unusual combination—the relative formality and uniformity of a brick surface through which passes an apparently natural stream—yet it works. One might think the patio was built up to an existing stream and pool, so well are they integrated. This effect is owing to the abundant planting, which belongs as much to the patio as to the stream, and to the credibility of the stream itself, which really does appear natural. Ample living area was left from which one may enjoy the sounds and sights of the flowing water, the swimming fish, and various aquatics.

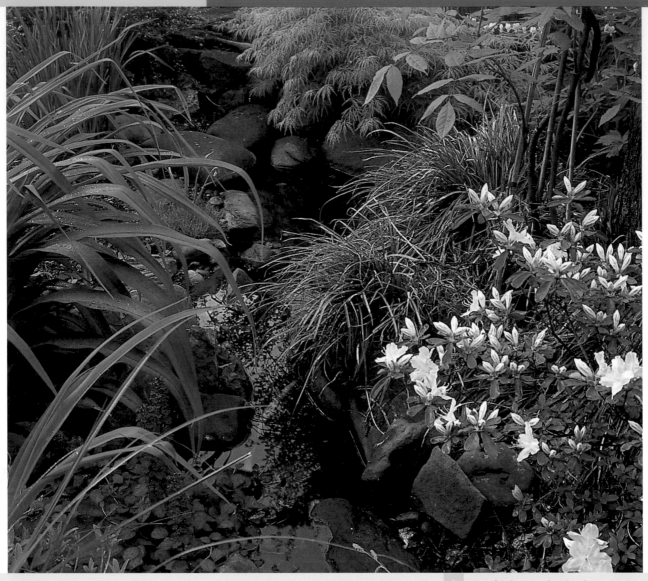

Graceful plants overhanging the steam contribute to its natural look.

Variations on a theme

An equally and perhaps even more effective treatment of this theme could be obtained by winding the course of the stream more to the left, with the primary patio area on the right side of the stream and a bridge across it. The result would be more visually dramatic as well as better balanced.

Where this style can be used

A landscape such as this could look good just about anywhere there is sufficient room—and not much is needed. This particular garden is in a small urban backyard, but the approach would be just as effective in a suburban neighborhood or rural setting.

Alternative bricked garden designs

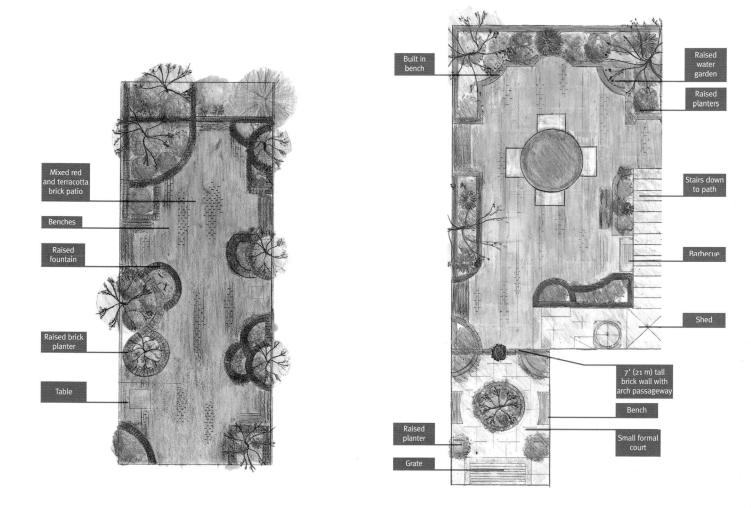

Mixed red and terracotta brick patio

Benches

Raised fountain

Raised brick planter

Table

Built in bench

Raised water garden

Raised planters

Stairs down to path

Barbecue

Shed

7' (21 m) tall brick wall with arch passageway

Bench

Small formal court

Raised planter

Grate

↑ A rectangular common red and terra-cotta brick base is given flowing motion by curved, raised brick planters at different elevations. From one such planter, water flows from the wall into a small pool beneath. The whole area is planted with flowering trees, shrubs, vines, and perennials.

↑ A small formal area opens into a brick courtyard bordered throughout by raised-brick planters with stone coping. A water garden occupies one corner, a barbeque is located by the steps that descend to the court, and benches are distributed around. A service area with a tool shed is situated to the edge of the design. Lushly flowering trees, shrubs, vines, and perennials abound.

Mosaic gardens

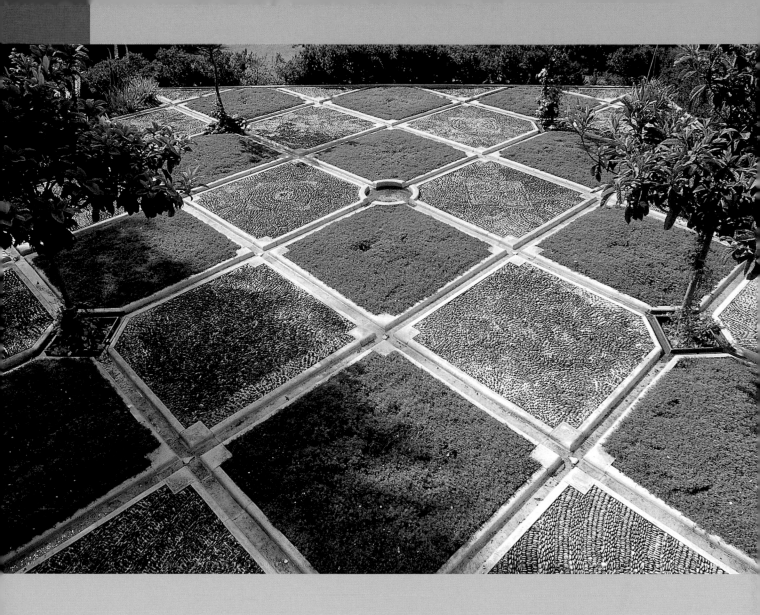

Though not often considered, a mosaic can make an excellent substitute for a lawn. Like a lawn, a mosaic can be used as paving while, unlike a lawn, it adds a distinctive ornamental quality. Further, a mosaic requires little maintenance.

While generally small in size, mosaics can be made of many materials other than tile and be used to cover considerable expanses. In fact, there is no garden that cannot be elevated by the inclusion of a mosaic, often as a substitute for grass. Here, we look at several kinds of mosaics of varying sizes and types.

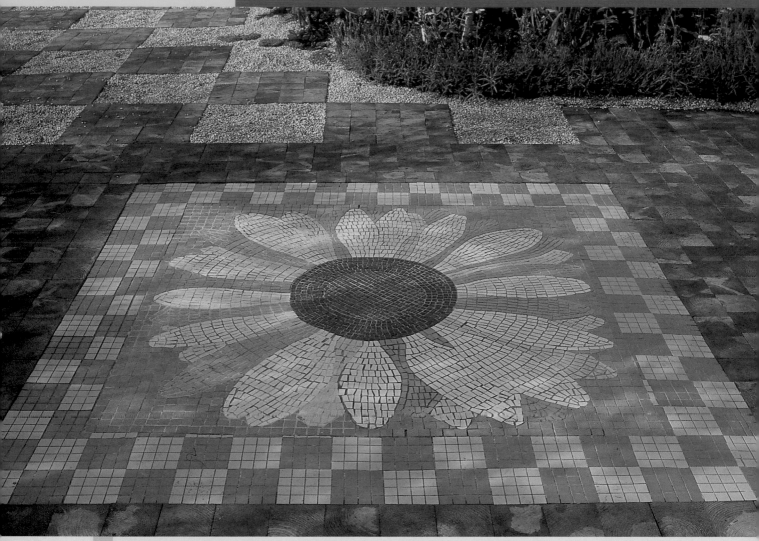

↑ A tile sunflower mosaic in a larger mosaic of wood and pebbles.

Tile in wood,
wood in pebbles

The look

This tile mosaic of a sunflower with a blue background on a wood patio is set within a larger mosaic of alternating squares of wood and pebbles. Had this area been planted with grass, it would have gone unnoticed. As it is, it leaps out as a bright, bold pattern in an interesting landscape bordered by flowering shrubs and perennials.

What works and why

This area is intended to be a walkable surface that is also attractive and interesting, and it succeeds in this completely. Why people relate to a checkerboard pattern—perhaps simply the comfort of its consistency—is unknown, but we do, and here we have it in an unusual combination of materials. The wood and gravel squares contrast in texture and color but also harmonize through the darker gravel and by their shape and size. At the planting edge, the checkerboard gives way to all gravel and at the patio area, to all wood, with the mosaic inset.

The border of the mosaic forms a pleasant contrast with the surrounding wood while harmonizing through the alternating light and dark squares of the same size as the wood insets forming the patio. The sunflower picks up the lighter colors of the gravel as well as the darker colors of the wood. Through these harmonies each area of the garden is related to the others, creating a consistent whole—yet the whole is replete with bold contrasts.

The new in the old

Often in the pursuit of originality we create something novel but not enjoyable. It is interesting but offers nothing that we can relate to. One way to create something original yet acceptable is to work with recognizable patterns or common objects in a new way. An ordinary table surfaced in a different material, a wall constructed of materials not normally associated with a wall, a planting bed in an unusual shape, can be refreshing without alienating us.

Variations on a theme

Sizes, shapes, colors—all these can be altered without significantly changing the design. For less vivid contrast, change the blue border of the mosaic to a lighter color more in harmony with the petals of the sunflower. The pebble squares could be flat pieces of stone, the wood could be brick, some of the squares of the checkerboard could be planted, and so on.

Where this style can be used

This design could be executed in a suburban front garden, a suburban or urban rear yard garden, or a courtyard. Properly scaled, it could occupy either a small area or a large area.

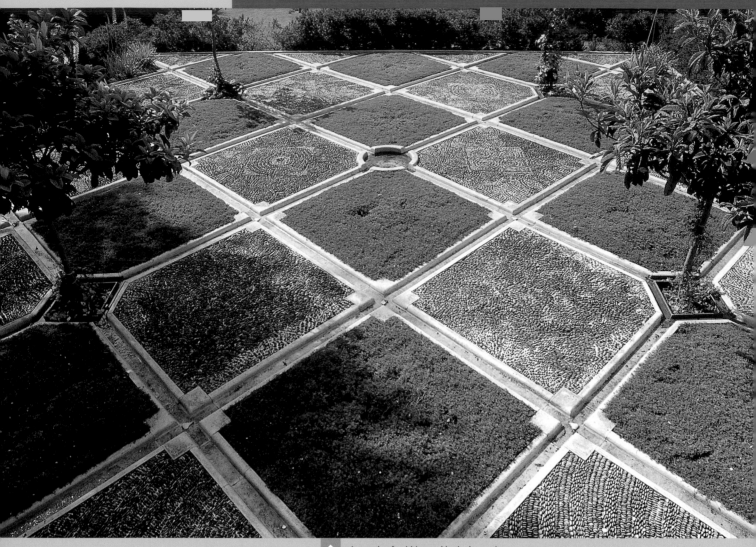

↑ A mosaic of pebbles and herbs in regular
squares separated by troughs of water.

French pebbles
and herbs

The look

Where typically a large *tapis vert* (green carpet) would have occupied this space, here, we see uniform squares of pebbled mosaics regularly interrupted by plantings of herbs, with a water source in the center. Each of the pebble squares is an individual mosaic. The alternating squares of herbs and mosaics separated by troughs create one large mosaic. The infrequent but regular tree Eriobotrya is one large mosaic.

What works and why

This design is intended to yield a low-maintenance, highly visible garden that is at once soothing and satisfying. In this it succeeds. The central pool with channels leading to the trees and the parterre placement of the mosaics and herb squares create the atmosphere of a modern-day cloister garden. Note too, the pebble work. This attention to detail in their placement is vital to the success of the garden.

This garden strikes a good balance between its refreshing and tender qualities and its practical strength and durability. Had only pebble mosaics been used, the scene would have been too hard and too hot; if only plants, too weak. Further, the primary components of mosaic squares and herb squares form a distinct contrast, while the rough texture of the thyme picks up the pebbly quality of the foliage, thereby uniting these distinct materials in a pleasing vignette.

The role of detail in a large expanse

Details and ornament are always important in a garden. In a large expanse characterized by broad elements, details are vital to pulling the viewer into the scene. Without their effect, the garden is seen only as a space. With them, it is experienced as a place—and a place made more pleasant by the attention given to its creation.

Variations on a theme

The basic design can easily tolerate a range of variations. The squares could be made to other sizes and shapes, the mosaics made of other materials, and the herb beds made of a different plant or more than one plant. More than two alternating primary elements could be used; a planting bed could replace the central water basin; and the troughs could be planted, as in parterre work, paved in a material that contrasts with the surrounding elements, or eliminated altogether.

Where this style can be used

As shown here, this design requires considerable space, but scaled down, the motif could be used in much smaller areas and to considerable effect with only slight variation. The mosaics and herb plantings at one third or one fourth the size would make a fine patio or seating area. In a location with considerable shade, different plants would work as effectively.

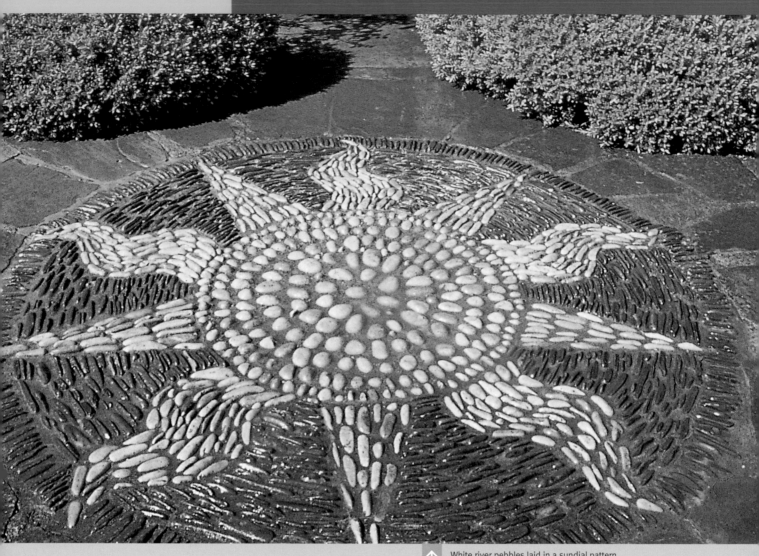

White river pebbles laid in a sundial pattern and offset by black pebbles laid on edge in a circular design form a distinctive entry.

A river pebble
sundial

The look

Where typically a large *tapis vert* (green carpet) would have occupied this space, here, we see uniform squares of pebbled mosaics regularly interrupted by plantings of herbs, with a water source in the center. Each of the pebble squares is an individual mosaic. The alternating squares of herbs and mosaics separated by troughs create one large mosaic. The infrequent but regular tree Eriobotrya is one large mosaic.

What works and why

This design is intended to yield a low-maintenance, highly visible garden that is at once soothing and satisfying. In this it succeeds. The central pool with channels leading to the trees and the parterre placement of the mosaics and herb squares create the atmosphere of a modern-day cloister garden. Note too, the pebble work. This attention to detail in their placement is vital to the success of the garden.

This garden strikes a good balance between its refreshing and tender qualities and its practical strength and durability. Had only pebble mosaics been used, the scene would have been too hard and too hot; if only plants, too weak. Further, the primary components of mosaic squares and herb squares form a distinct contrast, while the rough texture of the thyme picks up the pebbly quality of the foliage, thereby uniting these distinct materials in a pleasing vignette.

The role of detail in a large expanse

Details and ornament are always important in a garden. In a large expanse characterized by broad elements, details are vital to pulling the viewer into the scene. Without their effect, the garden is seen only as a space. With them, it is experienced as a place—and a place made more pleasant by the attention given to its creation.

Variations on a theme

The basic design can easily tolerate a range of variations. The squares could be made to other sizes and shapes, the mosaics made of other materials, and the herb beds made of a different plant or more than one plant. More than two alternating primary elements could be used; a planting bed could replace the central water basin; and the troughs could be planted, as in parterre work, paved in a material that contrasts with the surrounding elements, or eliminated altogether.

Where this style can be used

As shown here, this design requires considerable space, but scaled down, the motif could be used in much smaller areas and to considerable effect with only slight variation. The mosaics and herb plantings at one third or one fourth the size would make a fine patio or seating area. In a location with considerable shade, different plants would work as effectively.

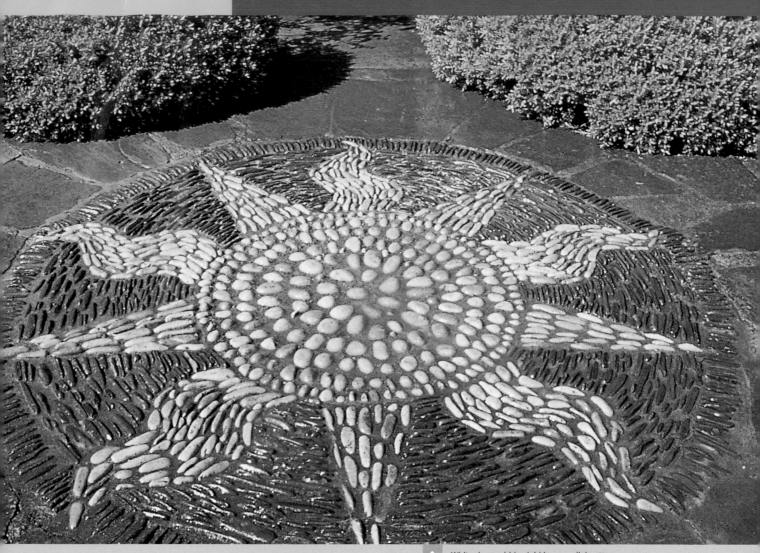

White river pebbles laid in a sundial pattern
and offset by black pebbles laid on edge in a
circular design form a distinctive entry.

A river pebble
sundial

The look

How much more elegant and enjoyable is this mosaic laid in a field of stone than a typical lawn with walkway. It is at once exciting, cheerful, whimsical, and durable, requiring no maintenance beyond an occasional sweeping. Bordering shrubs soften and give balance.

What works and why

The mosaic is simple yet extremely well done. The center of the sun is a perfectly round stone, while all the other stones are tapered, laid with the narrow end toward the center, radiating outward. Circular lines created by black stones laid on edge create a textural and color contrast. These are laid with the smaller stones on the inside, the larger on the outside, and contribute both to the vitality of the mosaic as well as adding dimensionality. For a finishing touch, a ring of these black stones circles the sun, blending into the surrounding polished paving stones. These are also laid in a circular pattern around the sundial, continuing the sense of motion and flowing and fading into the planting beds beyond.

The gray of the mortar is essentially the same color of the paving stones; the continuity of color binds the entire creation, expressing the relationship of the disparate elements. This unification of the whole permits the contrasts—the black and white stones of the sundial, the perpendicular flow of lines, and the textural contrast between the pebbles and the paving—lending a richness through variety without mitigating the singular sense of place this mosaic garden conveys.

Variations on a theme

Local stone varies by region, but there will always be pebbles and paving stones with which a creation such as this can be made. The key here is not the specific stone but, rather, the quality of the concept and its execution.

Where this style can be used

Although this design would not fill as an entire suburban front yard, it would make an excellent portion of one and would do well as either a front or rear garden in an urban setting and as a portion of a garden in a rural area.

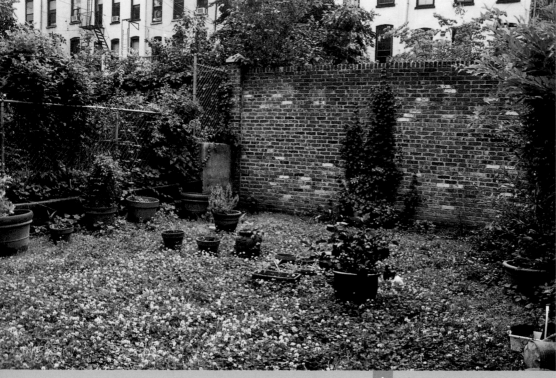

After installing a rear wall, the space was merely a grassy backyard.

From lawn
to lovely

The look

This backyard lawn was a great place to raise crickets, perhaps, and maybe even to practice playing cricket. Sunbathing was certainly an option if you didn't mind the hundreds of windows looking down on you, but it was not what you'd call a garden, and it certainly wasn't pretty.

Though the area is small, the new design called for dividing the space into several separate but integrated areas. The goals were to make the yard look and feel larger, to make it more usable, and to permit the creation of an attractive garden. The paving is a random mosaic of variously sized bluestones framed in the same brick used in the rear wall and in the planters. An arbor, soon to be covered in vines, joins the two main areas, while two in-ground beds, planted in box, create the separation between them. A garden room of lattice over brick, inset with glass blocks, provides a place for private sitting, dining, and enjoyment, and a wall fountain provides the gentle sound of water falling delicately into water. Raised beds of brick capped in the same bluestone used in the paving are the primary planting areas throughout the garden.

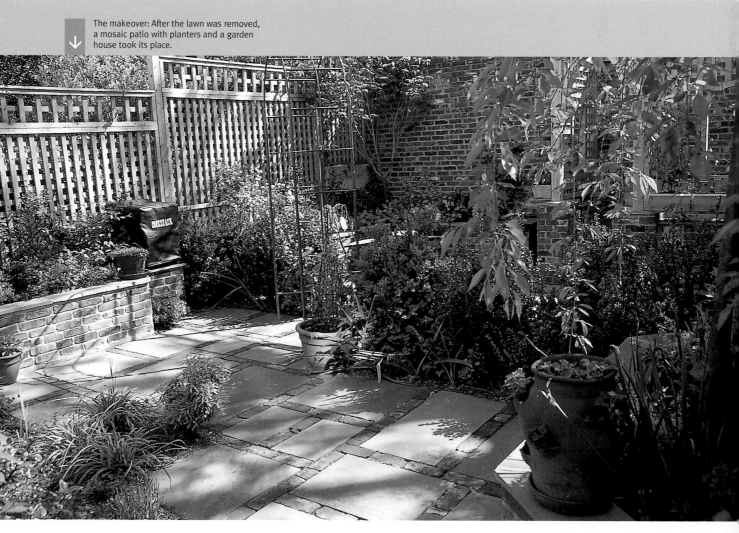

The makeover: After the lawn was removed, a mosaic patio with planters and a garden house took its place.

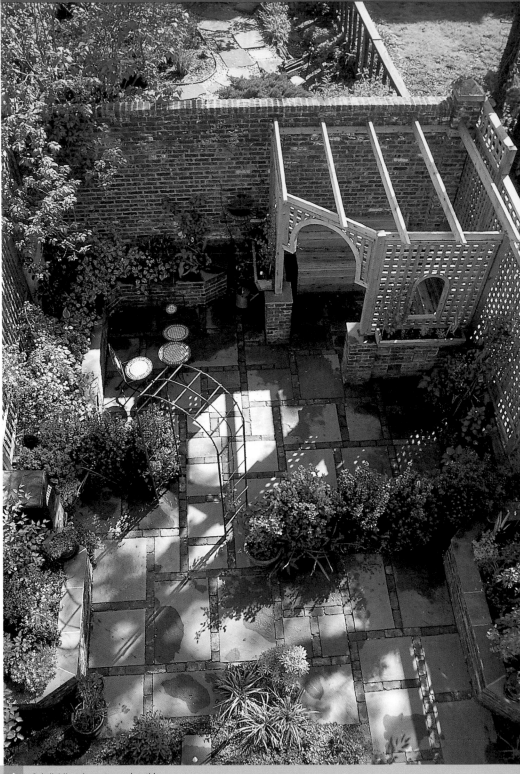

Subdividing the space makes this
backyard an extremely functional
extension of the home.

What works and why

The division of space is an important element in this garden's success. First we find a front room of ample size, and from there we are invited into another room beyond, and thence to the lattice enclosure. The low planters are large enough to accommodate numerous plants but not so large as to encroach on the living areas. Each room invites use, and each leads naturally and easily into the next. It is this succession of spaces, with each being large enough to make one feel comfortable, that gives this garden its sense of amplitude.

Most of the structural elements in the garden—the raised planters, the paving, and the garden house—are made of bluestone and brick—which, in conjunction with the brick wall, help unify the area. There is also a harmony of forms. The angular planters repeat across the garden, as do the in-ground planting beds. The arch of the garden house windows is repeated in its entry, in the adjacent arbor, and, on a horizontal plane, in the wall fountain, which can be seen and heard from most parts of the garden.

The cedar lattice fencing creates privacy without an oppressive sense of enclosure. Likewise, the garden house—one feels removed from the unseen eyes in the surrounding buildings without feeling confined. The green and blue glass blocks built into the garden house walls also help lighten the structure.

What is a garden?

Normally, when we think of a garden, we think of plants planted in the ground—and, in fact, that is the first dictionary definition of the word. In the past, that is pretty much what gardens were all about. People took pleasure in growing ornamentals or supplementing their larder with vegetables, but they didn't think of the garden as a room—a place to live. The dictionary's second definition refers to a planted park, but parks are not so plentiful anymore and outdoor spaces where people spend time are far less accessible than in the past. This is why today's gardens are somewhere between and including these two definitions. They are places planted with ornamentals and, often, vegetables and herbs, but they are meant to be used like a room in the house.

This is why the delineation of space in gardens is so important. They need to be made livable, inviting, pleasurable places, with areas for sitting in the sun and sitting in the shade and outdoor cooking and dining and entertaining and so on. No longer can a garden be considered only a place to grow plants; it is now a place made beautiful with plants in which to live the quieter, happier moments of one's life.

Variations on a theme

This mosaic was created out of random rectangular pieces of stone, but a uniform size, edged in brick, would have worked well, too. The garden room could have been a different size and shape, the lattice could have been diagonal, the glass blocks more numerous or not used at all, and the planting scheme infinitely altered. None of these changes would seriously alter the general layout and motif of this garden.

Where this style can be used

This general approach would suit many urban plots. It offers planting space, living space, and privacy in a garden environment in the heart of a city.

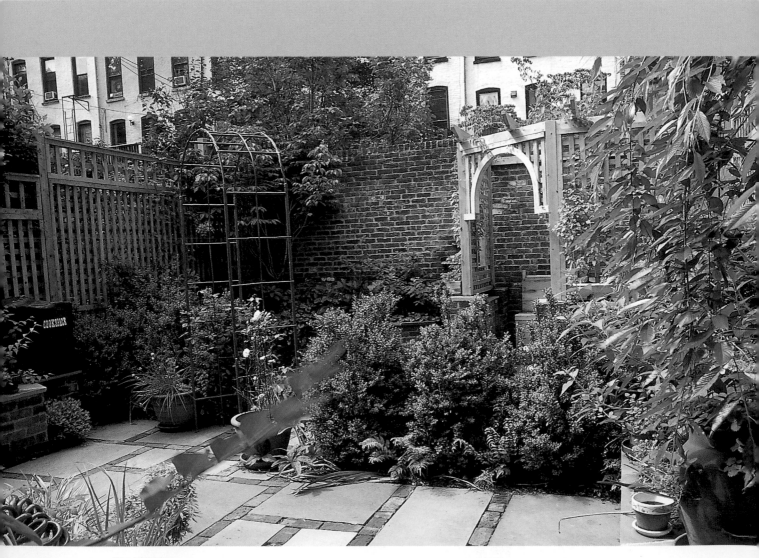

Alternative mosaic garden designs

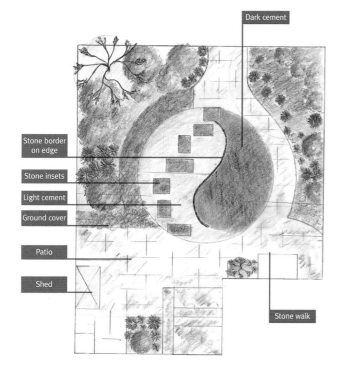

Stone border on edge

Stone insets

Light cement

Ground cover

Patio

Shed

Dark cement

Stone walk

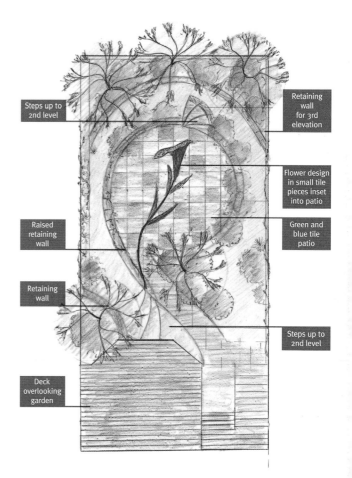

Steps up to 2nd level

Raised retaining wall

Retaining wall

Deck overlooking garden

Retaining wall for 3rd elevation

Flower design in small tile pieces inset into patio

Green and blue tile patio

Steps up to 2nd level

↑ A small patio looks out onto a yin-yang symbol created in light and dark cement, separated by a stone border. The light cement portion has stepping stone insets built into the design, while a path of the same stone wraps around the dark side. A border of ground cover embraces the left portion and both sides and the rear are bordered in a dense planting of shrubs and perennials.

↑ A deck overlooks a patio in blue and green tiles inset with a flower motif in smaller tiles. The patio is enclosed in a retaining wall wrapped around it, behind which you'll find plantings of low-growing ground cover and a few shrubs. A second retaining wall supports a third level, planted in trees and shrubs. Flowering vines border the site.

Flower gardens

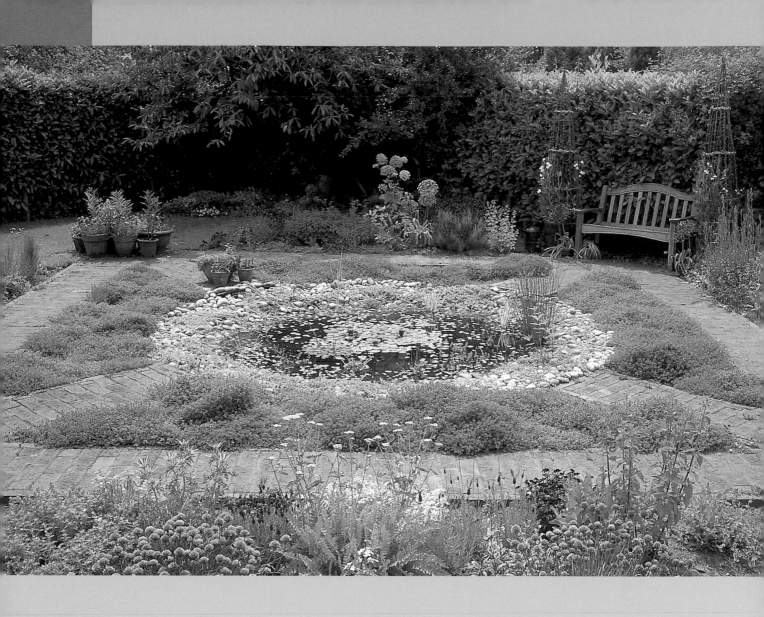

There are many reasons to choose a garden style other than lawn, some of which have nothing to do with time or upkeep. Some people simply like a lot of plants and don't want to waste space on green carpets. Such gardens may require more work than a lawn, but they give their owners many months of satisfaction and happiness tending and cultivating them. Here, we look at several gardens in which space is given over to flowers and herbs, with just enough paving to permit access.

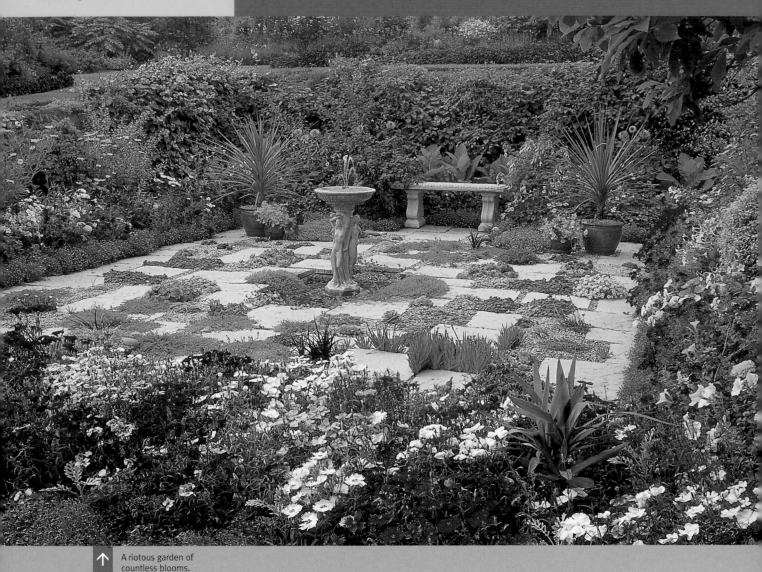

↑ A riotous garden of countless blooms.

Pavers, herbs,
and blossoms everywhere

Mediating elements

Often, you can successfully combine disparate or highly contrasting elements by using a mediating element that possesses qualities found in both. Opposites in color, form, size, texture, etc., can be brought together by including values that bridge the gap between them. For example, a tall, narrow plant can be harmonized by an intermediate plant with a straight trunk and a rounded weeping head.

The look

This area would typically contain a lawn and, in times past, did so. Now, pavers interspersed with herbs and perennials occupy the center, while a riot of blooming perennials and annuals occupy the four borders. This is a flower gardener's haven.

What works and why

There is a nice balance here between the nonfloral interior and the abundantly blossoming borders. The former sets off and highlights the ebullient plethora of flowers. Though planted primarily in the red range, nearly every other color of the rainbow makes an appearance in splashes. This is certainly not a low-maintenance garden, especially considering the flowers are primarily annuals and must be changed several times yearly. But if you love color, this approach is hard to beat.

The few structural elements are important. The enclosing walls, covered in foliage, make a strong and mostly monochromatic backdrop to the rich floral display, while the bench, the central fountain, and the few planted pots give a much-needed solidity—an architectural component—to the massing of foliage and blossom. It is also good that the central area is a mixture of paving and herbs. Were it all herbs, there would be insufficient contrast to the borders, and we would feel lost in a jungle of plants. Were it all paving, the contrast would be too aggressive, and the borders would seem overdone and gaudy. The current arrangement helps the garden elements communicate graciously rather than argue.

Variations on a theme

The primary way to alter this motif would be to alter the plant selection. A different color scheme could be worked out in any hue with equal success. Even using only several shades of one dominant color would be dramatic in this setting. Because the garden contains mostly annuals, many color schemes could be employed in a single year.

Where this style can be used

Such a garden could be done anywhere, front or rear, urban, rural, or suburban. The scale can be changed to fit a given space; the essentials, a mixed paving and herb central portion with an abundance of flowering plants in borders, can work wherever the gardener has time to devote to such an abundance of plantings.

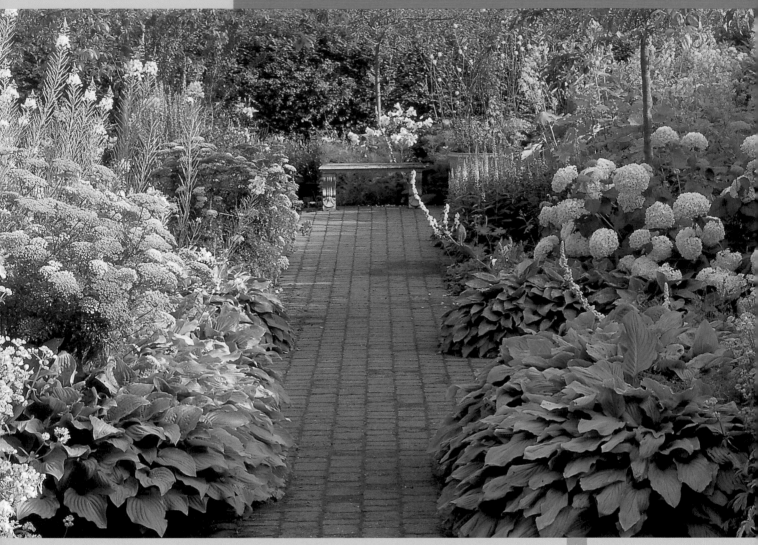

A plant-lover's paradise.

When plants are your passion

The look

In this lovely vignette, the entire area is devoted to ornamental planting. Just enough room is allotted to paving so the gardener can move about or sit on a bench to view the bountiful, blooming result of his efforts. This is a garden for someone who simply loves plants—looking at them, tending them, watching them grow, mature, and blossom.

What works and why

Too often, we would find in this situation lawn on either side of the walk. "What a waste," says the true gardener. Certainly we must acknowledge how much more beautiful, interesting, and infinitely more engaging this garden is than a lawn.

Although planting beds such as these may appear haphazard, they are, in fact, carefully planned, with attention paid to plant size, bloom time, and flower color as well as foliar qualities and variations in mass and texture. Note, for example, in the left foreground, the contrast of the bold leaf of hosta beneath the fine-textured achillea above, and, on the right, the bold globes of hydrangea blossoms against the spires of veronica toward the end. Likewise flower color—bright blue across from deep red and against light pink, pure whites with green-whites, white with yellow, lavender with blue—all contribute to the richness of the garden through their subtle harmonies and bold contrasts.

Leaf textures and mass values create an undulating rhythm throughout this garden to which the eye returns again and again, always with satisfaction and the perception of some new delight. Fine details, bold forms, the rising and falling and in and outs, the variations in solidity and the stepping up from front to back make this far more than a mere planting bed. It is a garden of relationships woven into a whole of endless enjoyments.

Variations on a theme

This theme—the perennial border with a few permanent plantings—has been varied countless times and always can and will be. Careful planning is the key to success in such a garden.

Where this style can be used

Although this theme has been created ten thousand times, it has not been tried in nearly so many venues as is possible. Most especially, suburban front gardens would be elevated by this treatment. If instead of the countless, mind-deadening lawns sprawling throughout suburbia there were more of these borders, even with lawns winding between them, the world would be a better place. Such beds also work in urban and rural gardens, front, back, or side.

Planning views

When planting a garden there is often a tendency to create our arrangements from a straight-on view so we place plants together that look good next to one another. And this we should do. However, many garden beds are seen from along their lengths and plants which are many feet apart are seen in relation to each other. These views should also be considered in the creation of such gardens.

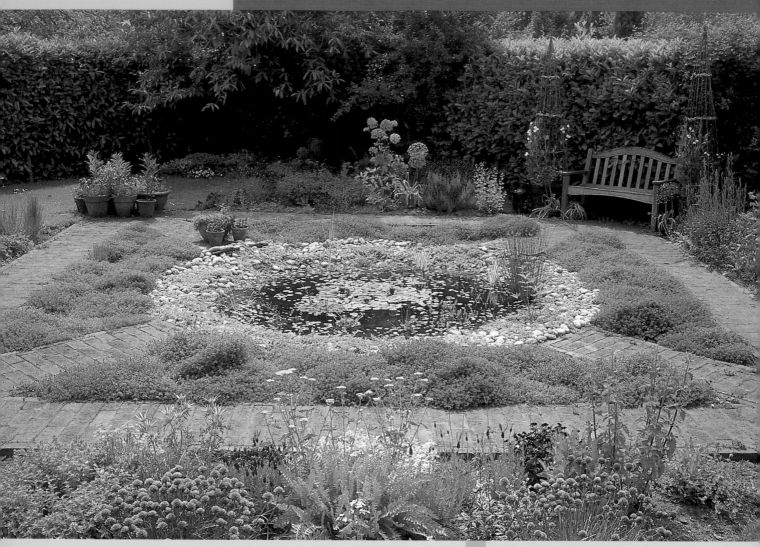

A circle within a square
and flowers everywhere.

A reason
for water

The look

This project might have been included in either the mixed-media chapter or the water garden chapter, but it is primarily a flower garden—the raison d'être of the water is to support the flowering plants. At one time, the entire space was occupied by lawn, but the central portion was transformed into a flower garden featuring a walkway, bordered by perennial beds, around an herb garden with a flowering pool. The bricked walk allows access to the flower pool from the four corners and offers an easy stroll amid the beds.

What works and why

The overall design of this garden is, in itself, without the details, a pleasant vision and a timeless motif. It is a square intercepted by a cross that is in turn intercepted by a circle at the center. The divisions created by this arrangement are familiar and pleasing to the eye, the layout peaceful and calming. This garden is meant for sitting in and strolling through, for reveling in the ever-changing floral displays set against the green backdrop of the thyme growing between the walk and the pool. The primary color scheme is lavender, with highlights of yellow and white. This scheme is boldly contrasted in the area near the bench, with the hanging baskets in red and white, and, to a lesser degree, the pool, with its carnelian water lilies. Everywhere else, cool shades of pale purple predominate. Clusters of clay pots, planted in the same shades, add a little dimensionality to the scene, as does the bench, tucked into a shady corner.

Water gardens and ornamental horticulture

When people think of plants and all the specimens they'd like to grow, they think of land, soil, and conventional gardens. There are, however, a wealth of foliage and flowering plants that can only be grown in water or wet soil. Some of these aquatics do not even need a pond but can be planted in plastic tubs buried in the ground with space between the soil and the top of the tub for water. The lotus is such a plant. These aquatics, whether in ponds, bogs, or pots, can extend the planting palette tremendously and add a wonderful variety to the conventional garden.

Variations on a theme

Many alterations are possible here. The water could have instead been an annual bed, and many other planting schemes could be tried. Further, the design of the whole could be modified—a circle with a square in the middle, for instance, or paths extending from the middle of the main walk rather than from the corners, would create as interesting and pleasant a layout.

Where this style can be used

With some modifications—for example, by eliminating the street-side walk and making a border on three sides—this design could be used to embellish a suburban front yard. Otherwise, nearly any rear property could support this motif.

Alternative flower garden designs

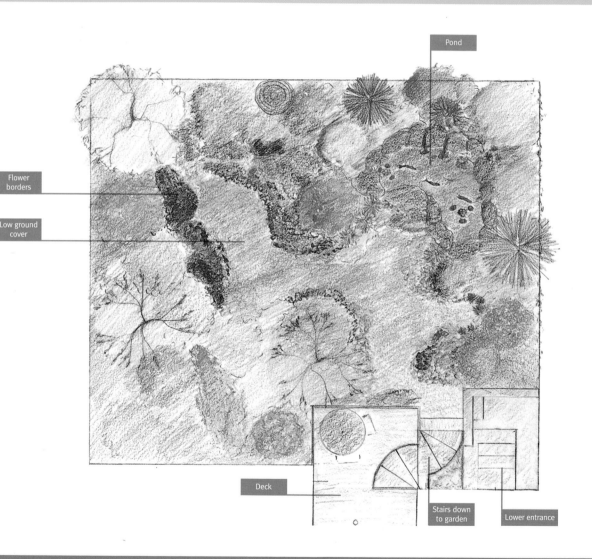

Pond

Flower
borders

Low ground
cover

Deck

Stairs down
to garden

Lower entrance

A raised deck looks over a garden composed of walkable
ground covers bordered by flower beds, flowering shrubs
and trees, and a small pond with a waterfall. Two half-spi-
ral staircases lead down to the garden.

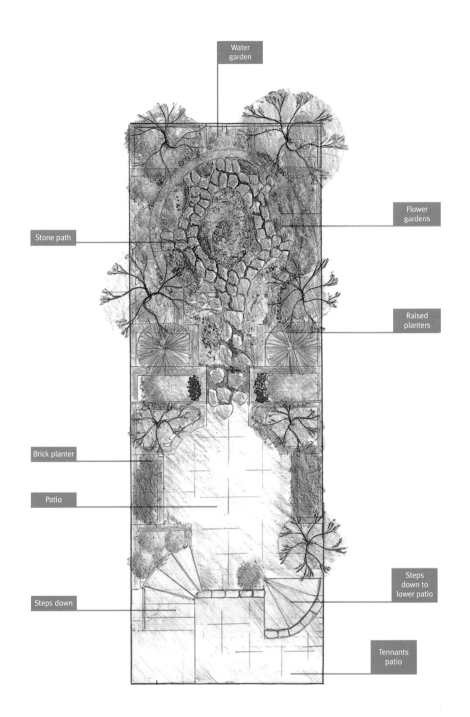

Water
garden

Flower
gardens

Stone path

Raised
planters

Brick planter

Patio

Steps down

Steps
down to
lower patio

Tennants
patio

A patio leads between raised planters to a stone path that
winds into a flower garden enclosed by a semicircular,
raised bed. At the rear is a raised water garden flanked by
two raised planters. Lattice fence runs along both sides
and the rear. The front patio is planted in greenery only,
while the flower garden contains a profusion of blossoms.

Gardens of wood

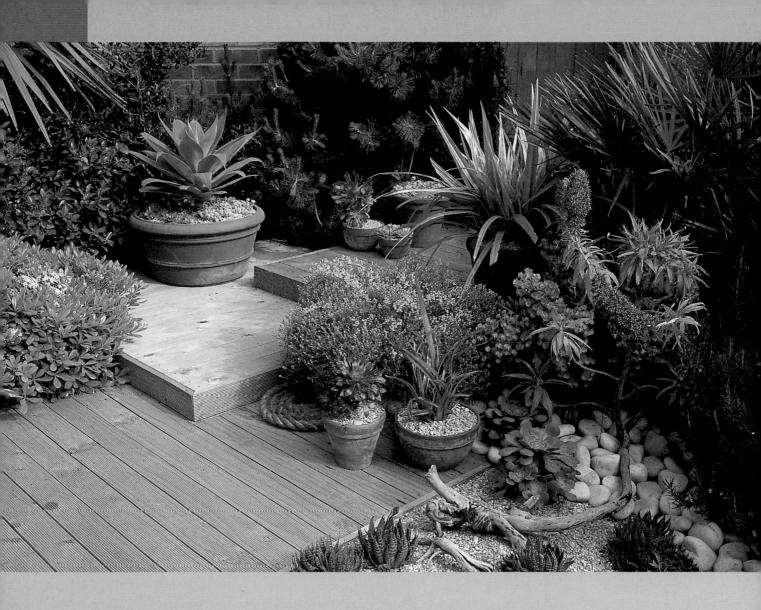

Decks are not uncommon, but it is too infrequently realized that, when well designed and built and thoughtfully planted, a deck can be a garden in and of itself. Too often, decks are barren affairs—utilitarian, certainly, a place to barbecue and such—but rarely attractive or really enjoyable. They may be used to look out over a garden but, as this chapter shows, a decked garden can be a wonderful world all its own, complete with abundant planting.

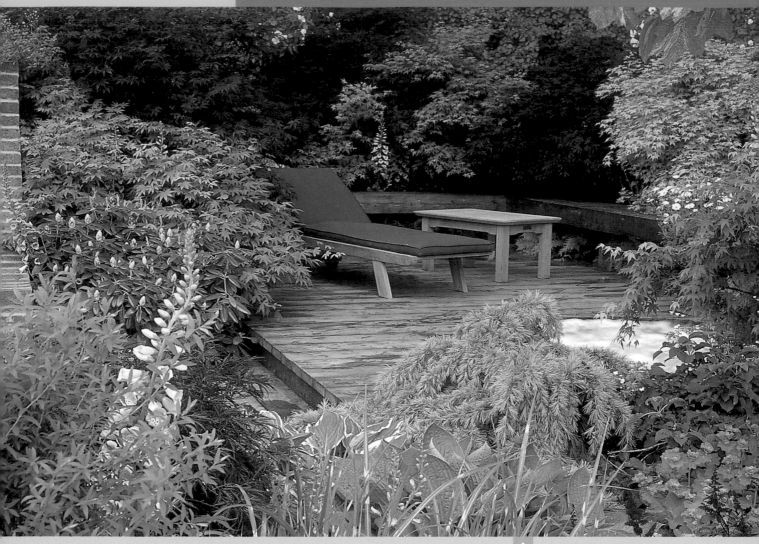

A beautiful deck with a spa ensconced in a planting of mature maples.

Spa style

The look

An elevated wood deck with built-in benches and a spa occupies the far corner of a rear property. The surround of mature plantings provides both beauty and privacy.

What works and why

This garden room lacks nothing. It is a beautiful place to sit and enjoy the lovely environment and offers as well the pleasures of a hot tub, dining, entertaining—even dancing in the starlight. The built-in benches along two sides provide plenty of seating, yet the deck is large enough to accommodate a table, chairs, and a barbecue as well as the chaise longue and side table.

The captivating beauty of this garden derives from the manner in which the deck is ensconced in a cultivated woods. The deck belongs to the garden, the garden to the deck, and they unite as a single place. It is as if one comes upon a clearing in the woods that has been civilized and cultivated.

The fine foliage of Japanese maples overhanging the deck softens its lines and adds an inviting texture, while ferns spill in beneath the benches, obscuring the angularity of the structure. This verdant wall extends from toe level to the sky, highlighted with burgundy maples, white roses and daisies, and rose and pink rhododendrons and foxgloves. As this leafy wall wraps the deck, it also creates a cozy corner for the hot tub, providing privacy in a natural setting.

Civilizing nature

Having spent ages escaping the uncertainties of nature in the development of a civilization, many of us find we are no longer completely comfortable in a completely natural environment. Nor are we completely comfortable in a completely artificial environment. When we can wed the two—creating a civilized space endowed with natural elements or a natural space that easily accommodates our wonted uses—we are happiest.

Variations on a theme

This is a simple garden comprising only the deck, the hot tub, and the plantings. Were more ornament wanted, planted pots—particularly glazed pots—would serve well. These could be placed along the edges, on the bench, and in the corners. More fragrant plants would add the dimension of scent and chimes, that of sound. Illuminated, this garden would at night be spectacular.

Were a hot tub not desired, the space it occupies could be given back to the deck. If there are young children to consider, a sandbox could replace the spa. Alternatively, a fire pit could be constructed if care were given to a skirt of stone or other nonflammable material, or a barbecue could be built into the deck.

Where this style can be used

This design would most likely suit a suburban or rural garden, as considerable room is taken up by the trees and shrubs—and, of course, it would need to be a rear or side yard. In an urban setting, the deck would need to be scaled down to accommodate sufficient planting, which is integral to the success of this garden. The next project illustrates this approach.

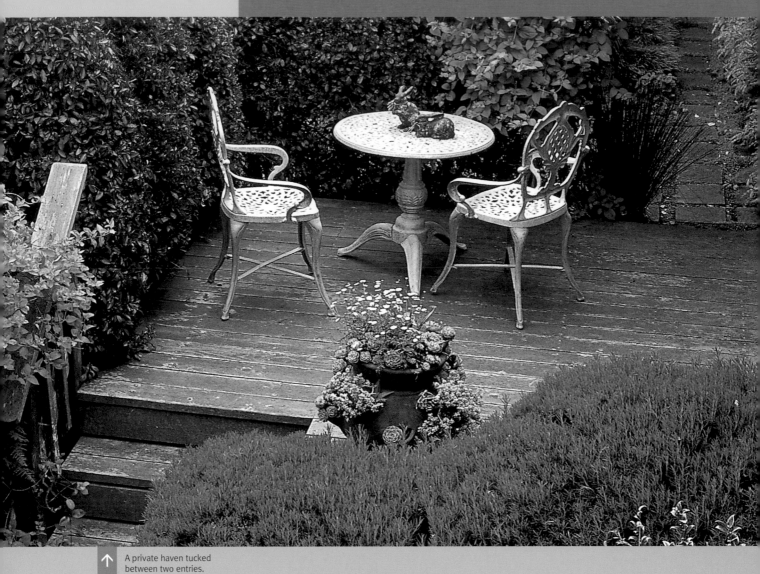

↑ A private haven tucked between two entries.

An urban haven

The look

A small alley leads to a deck enclosed by columnar shrubs and vine-covered walls. Steps descend on the opposite side and end off the deck to another walkway leading away. A few ornaments are placed about.

What works and why

This is a marvelous way to treat a relatively long, narrow site with both front and rear access and the perfect approach to creating a private garden area on any small urban property. Here, the deck is set midway between the two entry points but completely enclosed in foliage—thus achieving that elusive quality in city gardens, privacy.

A primary contributor to this sense of privacy is the manner in which the entry points are treated. Rather than an obvious path leading to an easily visible patio, plants have been brought in close on both sides of both entries, yielding a leafy bower on one side and a narrow avenue of plantings on the other. This treatment both shelters the patio from view and creates a sense of entry and of mystery on approach to the deck patio.

Though this small space is densely planted, it does not impose a sense of confinement or constriction. This is achieved in two ways: 1. by means of the vertical structures on which vines can grow into abundant foliage without taking up much space, and 2. by virtue of the narrow-growing eugenia, whose red foliage also provides a pleasant contrast to the bright greens of the honeysuckle. Though this is often not realized, 18 inches (46cm) of planting width, or even less, is quite sufficient for growing any number of plants, and when the upward dimension is maximized by planting along narrow but strong structures such as fences and arbors, a great deal of greenery can be supported on very little ground.

A philosophy for planting

In a botanical collection, each plant is often given its own space in which to achieve its mature size. It can, in this way, be observed from all sides, isolated and Independent of other plants. A garden, however, is another matter. Plants do not normally live in isolation, and neither do they look their best alone. Rather, they should be planted in sensitively arranged groupings with one plant allowed to grow slightly into another, each setting off the qualities of the other. When a portion of a plant begins to overwhelm another, remove that portion from its point of origin—for example, if the branch is coming off another branch, remove it from where it joins the other branch; if the branch originates from the base, remove it there rather than cutting a branch midway. The result of creating and treating a garden in this manner is a complex of happy relationships that is deeply satisfying both to see and to care for. Always carry your pruners into such a garden; snip a little here and a little there, and the garden will never look pruned, never look like it needs pruning, and will always be beautiful.

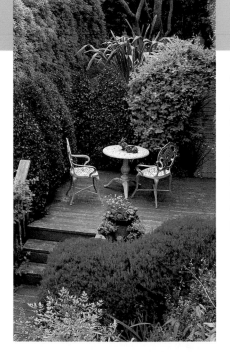

Variations on a theme

Any number of vines would work here, and in place of the eugenia, one could use Leyland cypress, various hollies, taxus, bamboo, Hinoki cypress, cryptomeria, grevelia, and other narrow-growing trees and shrubs. As with the last project, more ornament would serve well, too. Note the fine effect of the planted pot in the foreground. Such details add dimensionality.

Where this style can be used

The rear portion of a city plot is ideal for this style of garden. If neighbors wished to cooperate in a common garden, such an arrangement would unite two properties beautifully. A removed portion of a suburban lot also would accept this style; the approach would make a fine substitute for a lawn.

↑ A diminutive deck that, despite
its size, is missing nothing.

A little
of a lot

The look

A small deck laid in a field of pebbles steps up to another level and then, again, to a third level that in turn leads to a canvas-covered pergola. These tiers of decking support a variety of pots planted in succulents and other arid-region plants, some of which are also planted in the ground surrounding the decks. A brick wall topped in diagonal lattice encloses the garden.

What works and why

This is a fine example of how everything a garden needs can be contained in a small space. Here, we have abundant plants, attractive paving (the decking and pebbles), walking areas, foliage, and blossom. Room is made for sitting in the sun and for private contemplation in the shade of the pergola. Sufficient ornament raises the garden's inter-est, and though the space is really quite small, it feels richly endowed.

In part, the pleasure we derive from this garden comes from the effect of the decking. It is functional, of course, but it also serves as a foil, a backdrop to the plants and pots, which, by the principle of contrast, it sets off to advantage. The relative plainness of the deck's surface brings out the textural values of the surrounding elements and the living quality of the plants. Stepping the deck up to a third level adds dimensionality and, thereby, interest, and provides a vantage point from which to enjoy the garden from within the pergola.

Other charming aspects to this garden are the low brick wall with the lattice top, the contrasts and harmonies of adjacent materials, and the many details of the plants and plant groupings. The lattice top is nicely detailed; its fairly large diamond openings provide privacy without confining. The large and small pebbles combine well, and both look good with the deck, the plants, and the pots, while the smaller pebbles are also found in some of the nearby pots, generating a harmony within the contrast of elements. Finally, the plants themselves add a great deal of detail, delightful to the eye, particularly through their dramatic foliar qualities and the effective plant combinations found throughout the garden. Taken as a whole, this decked garden is masterfully done.

A garden is still to be seen

Many garden writers have in recent years emphasized, and rightly, the importance of making a garden livable, experiential, and not just a pretty place to look at. This certainly is vitally important, especially in these days of shrinking or disappearing green spaces; what little outdoor space we have on our own property is sometimes the only space we have for outdoor enjoyments. It should not be forgotten, however, that a garden is also meant to be seen, and it behooves us to create places in or adjacent to the garden from which we may see and enjoy its visual beauty to its best advantage.

Variations on a theme

Though this garden is complete in itself, executed in a larger space the design could be expanded in all its aspects—more decking, more plants, and so on—to good effect. Although the canvas-covered pergola works well and adds a pleasant textural contrast, a vine-covered pergola of another material, such as wood or, perhaps more effectively, iron, would also form a lovely seating area. In another climate, equally dramatic orna-mentals could be used in place of these arid-region plants.

Where this style can be used

This plan could be made to work well in almost any suburban, urban, or rural setting. It would be especially appreciated just off a room of the house, such as a kitchen or living room, from which it could be enjoyed—even when not in use.

Alternative designs for gardens of wood

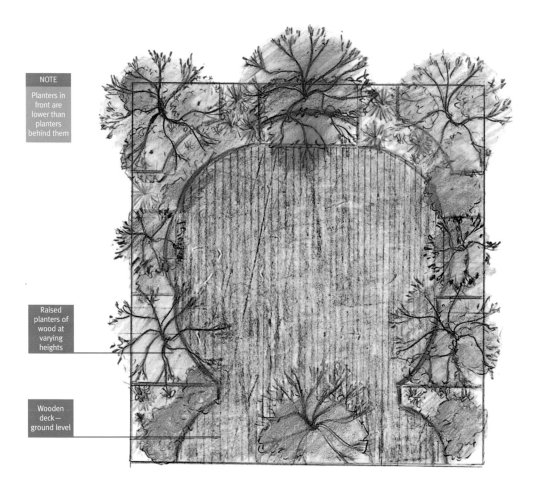

NOTE

Planters in front are lower than planters behind them

Raised planters of wood at varying heights

Wooden deck— ground level

A wood deck is bordered on three sides with curving wood planters of different heights. The planters ascend in height toward the center and descend at either end. The planters in the front are lower than those in the rear. They are planted lushly in small ornamental trees, flowering shrubs, perennials, vines, and annuals.

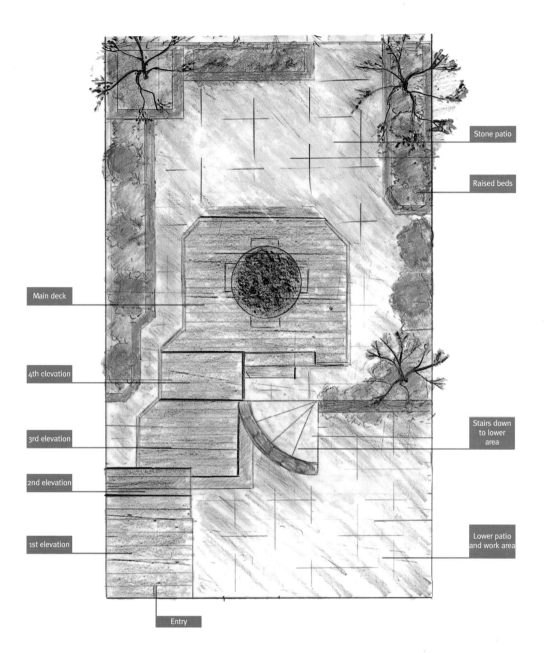

Stone patio

Raised beds

Main deck

4th elevation

3rd elevation

2nd elevation

1st elevation

Stairs down to lower area

Lower patio and work area

Entry

A small wood deck off the entry to the garden descends through several levels to the main deck, which is surrounded by paving and low raised beds. Steps lead down to a lower level—useful for storage or tenant's use.

Gardens with water

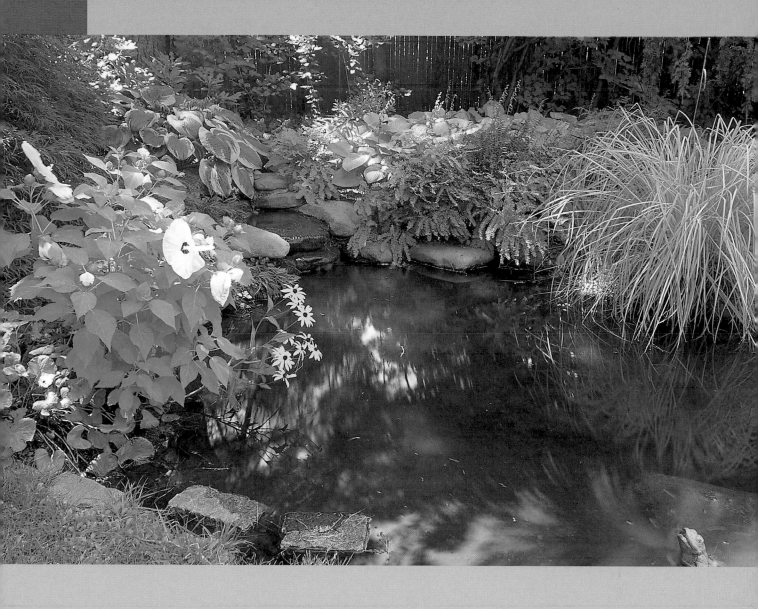

A lawn, however mundane, does provide a cool, inviting softness—and a wonderful way to replace lawn while retaining that quality is to employ water. Water features are no longer problematic, nor do they require much time in upkeep. Once a balanced ecosystem is achieved—and that is not difficult to do—water gardens remain fairly problem free. Yet nothing is quite so magical, so delightfully captivating as a water garden and the many exotic plants, fish, and other life it can support. In this section, we look at several garden sites in which a lawn gave way to a water feature. Each of these is low maintenance, requires less time than a lawn, and provides its owners with enormous satisfaction and pleasure.

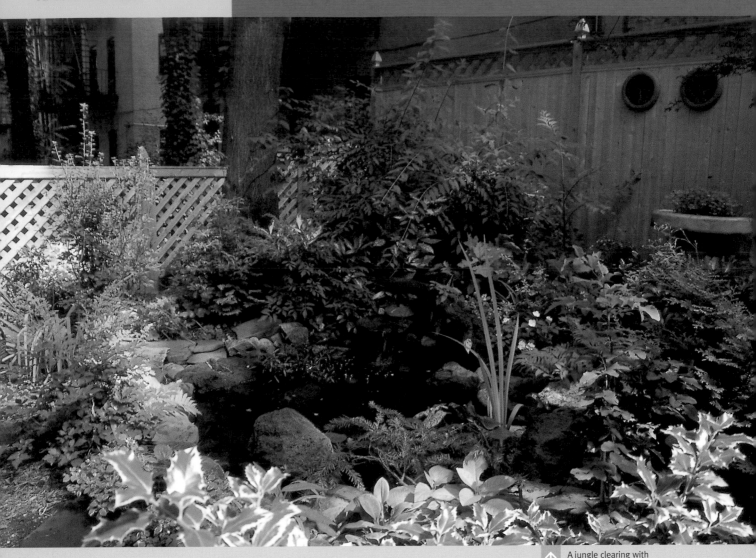

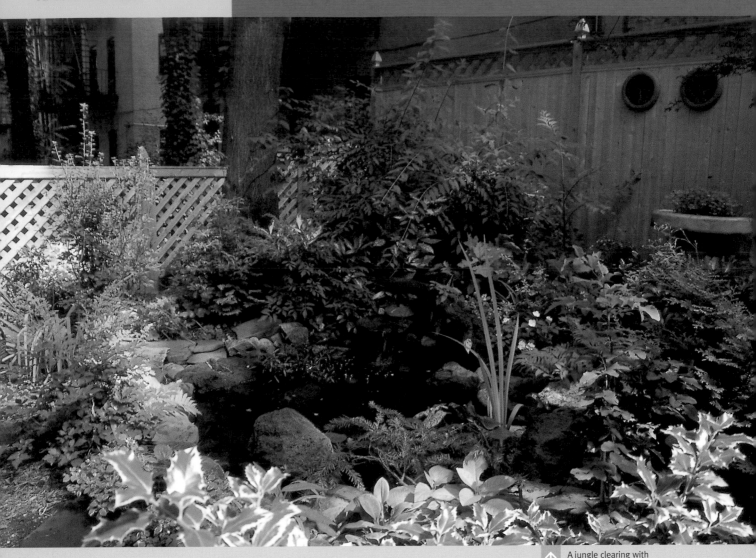 A jungle clearing with a pool in the center.

A jungle pool

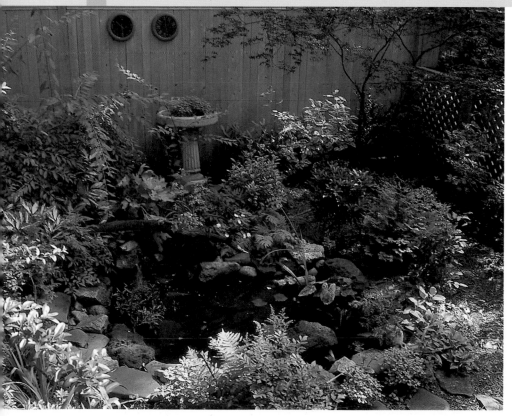

The look

Originally, this was an overgrown garden lacking definition and focus, except for the planted porcelain sink. Shade from the overhanging ailanthus tree precluded grass and besides, the owner didn't want a lawn. He did, however, want something that would soften, relax, and bring focus to his yard, plus interest and liveliness. He wanted a water garden. Placed in the center of the yard, it became the focal point of the garden, especially as seen from the deck, 4 feet (1.2m) above it. A waterfall provides visual and audible enjoyment, and the koi are a prime attraction.

What works and why

This garden, in another setting, might not be impressive, but as an urban backyard, it has quite an impact. We just don't expect to find a jungle pool on a city lot. Although wood-chipped pathways allow access around and behind the pool, it is, for the most part, ensconced in foliage, with plants dangling over it, covering the edges and growing up from within. The density of the planting behind the waterfall implies a hidden source for the pond, and we might believe this is a natural pool fed by some unseen trickle of a stream or artesian well. The bench provides a vantage point from which to observe and appreciate the aquatic life.

In small urban spaces it is often desirable to create illusion, particularly the illusion of space and abundant nature. We use trompe l'oeil and mirrors, we install streams and ponds, and we frame views into neighboring trees to expand the experience of our garden. For these to succeed it is often necessary to blend these devices into the garden by slightly obscuring their boundaries or their origins. If we can easily see where a tromp l'oeil creation begins and ends, the effect is lost. In order to capture neighboring landscapes as if part of our own careful planning and planting, it is necessary to unite the garden with the outside world; for a stream to be effective in a small urban space, its origin or source should be obscured by plantings.

The waterfall, with the fallen branch and well-placed stones, contributes to the sense of a natural pool.

Variations on a theme

Because the deck overlooking this garden is the garden's primary living area, the pool could be set in the center of the space. In a setting in which the entire space must provide planting as well as living areas, the pool would be better placed off in a far corner with plants around three-quarters of it and paving in front. With a strong design and abundant planting, the jungle pool effect would still be obtained.

Where this style can be used

This garden would be well placed in many urban settings and in any suburban or rural setting. Where the space is greater, the pool could be larger, with more plantings. In a smaller space, the pool would still be effective at half the size and with smaller plantings around it.

↑ Before. A dismal scene
in concrete.

From dismal
to formal

The look

As the before picture shows, this yard was a concrete den with a small rectangle that had, over the years, been planted in many ways. A wild cherry grew up next door, overhung the property, and now cast too much shade for many plants. The spruce, though lending a formal elegance and able to survive low light, was too hard an influence. A softer, more soothing and inviting element was needed to occupy the place of prominence. A lawn would have worked aesthetically, but there was too much shade. A water garden was the perfect solution. As the expense of replacing the concrete was out of the budget, the pool had to conform to the established, formal lines, and the rest of the property required like treatment.

The rectangular planting area was enlarged slightly to accommodate a water garden plus room for planting behind it and to the sides. This much removal of concrete was manageable. The old fence along the left side was removed and lattice with a different lattice top was placed along both sides. Formal arches were built in—three to a side, separated by semicircles of brick planters with flamed-edged bluestone coping. Concrete was removed in the rear portion of the garden, and that area was planted with the existing spruce in the center, flanked by river birch and various vines, shrubs, and perennials.

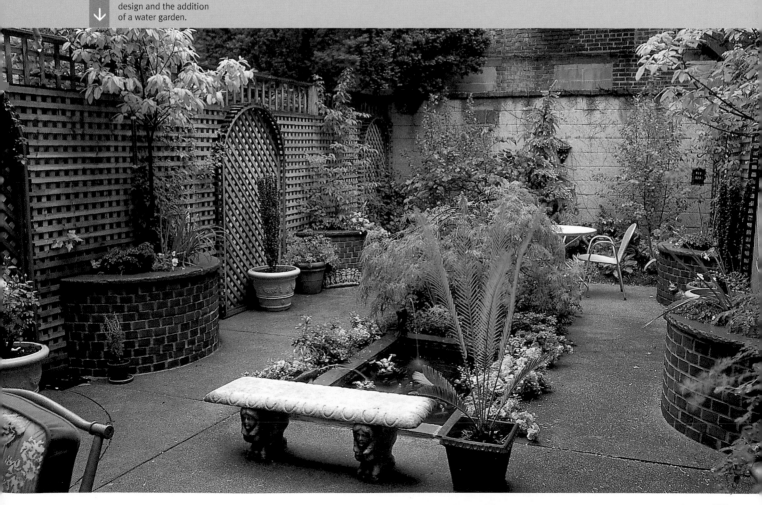

The same scene, after design and the addition of a water garden.

What works and why

The strong symmetry—each side along the main axis is a mirror image of the other, the three arches separated by three half-circle planters—brings a sense of reliability and comfort, but its strength is softened and relaxed by the numerous details and seemingly random placement of ornaments. The garden is clearly formal in its design, yet the plantings, for the most part, are free form and natural. This creates a balance between the two paradigms of formality and informality, neither allowed to overwhelm, which creates for us a pleasant contrast.

In like manner, the water garden conforms to the formality of the layout, reflecting the entire site in shape, yet it is planted with variegated foliage and pale pink blossoms that soften the edges and convey a sense of lightness and light-heartedness. The fish fountains, likewise, contribute to the gentle elegance. At the far end of the water garden, plants are tiered upward from ferns at the bottom to the threadleaf maple and the red-leafed Cercis canadensis. Back to the rear of the garden, this tiering continues in the spruce and the river birch. This layering carries the garden upward in a gentle sweep, pleasantly expanding our experience of it.

The function of transitions

Planting arrangements of sharply contrasting elevations, such as a tree and ground cover, without intermediary levels of planting can be a dramatic way of adding excitement to a scene. In most situations, however, such compositions are experienced as abrupt and dissatisfying. Generally, a transition from low to high with several levels between is the most enjoyable planting arrangement.

A formal water garden and latticework paired with arches, planters, and benches create an elegant feel in this space.

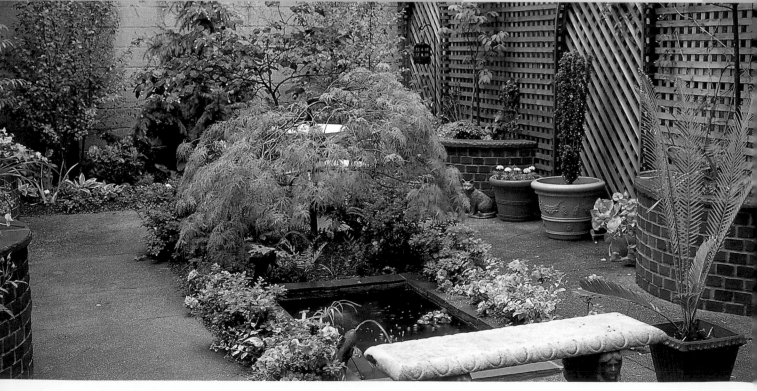

Variations on a theme

This garden could be altered in many ways without losing its charm. A circular or oval water garden might have worked, the planters could have been made of stone or cast stone, the spruce in the rear could as well be a pergola from which to enjoy the view of the garden, the planting could be altered, lattice could cover the rear wall, and so on.

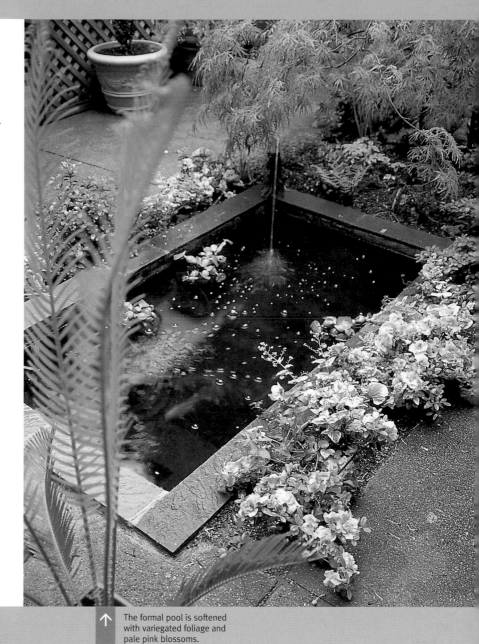

↑ The formal pool is softened with variegated foliage and pale pink blossoms.

↓ Fish fountains bring a touch of lightness.

Where this style can be used

This is almost exclusively a city garden design. It would be difficult to make such a layout seem appropriate or genuine in a suburban or rural setting unless great pains were taken to contain the garden in a strong structure surrounded by strong plantings.

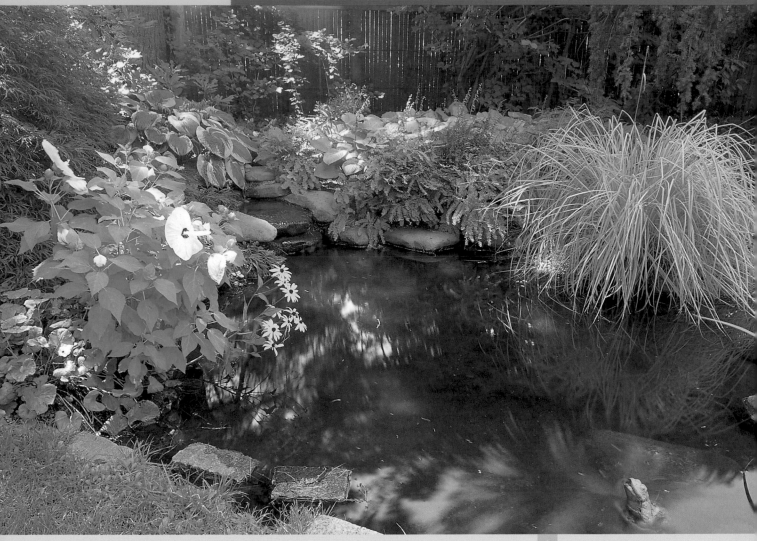

A stream flows from an unseen source into a tranquil pool.

Rural wildlife
refuge

The look

A large portion of a rural backyard previously dedicated to lawn was transformed into a water garden replete with a running stream, extensive pools, and boggy areas. The result, of course, is a haven for countless creatures, many of whom make this their year-round home, others their summer vacation spot, and still others a stopover on their annual journey to distant lands.

A strong backdrop of large trees and a vine-covered fence border this watery world, providing a needed sense of containment. Abundant perennials and shrubs sprawl about aimlessly, forming both feeding grounds and safe havens for the myriad creatures.

Nature sports

Suburban lawns are often the sports fields for children and teenagers, but not all yards need to be given over to these uses. With a little cooperation, some backyards could be grassy playing grounds and others dedicated to natural havens with ponds, streams, and the wildlife such havens naturally support. Such a use would provide a different range of activities and an enjoyable arena for an enriching education in nature studies.

What was once a lawn is now an aquatic world of flora and fauna.

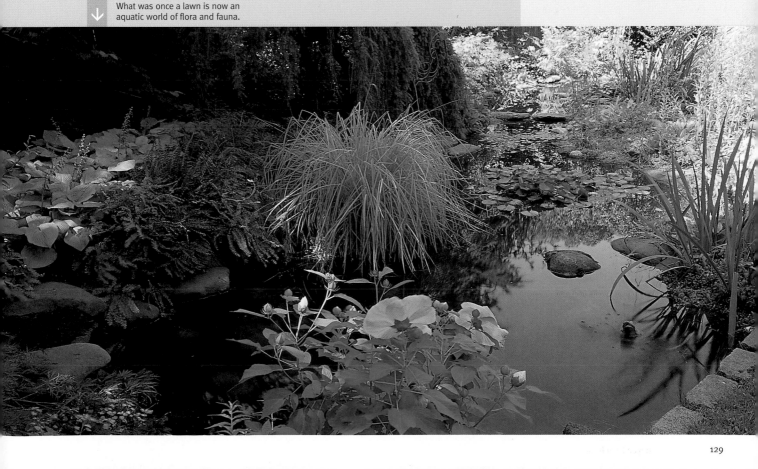

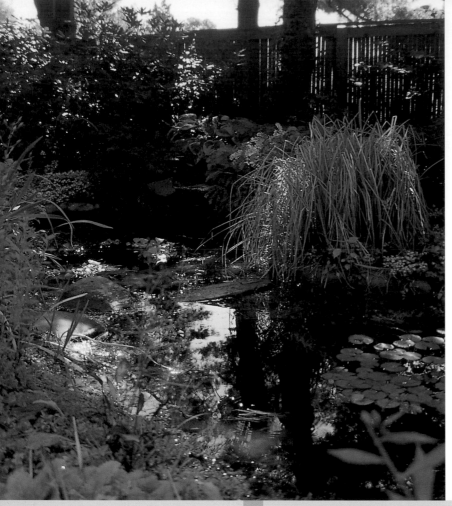

What works and why

In a rural property with plenty of space, this water haven makes a delightful contrast to our sometimes overcivilized world of mani-cured lawns, pampered plant beds, and clean-lined patios. One can spend hours, days, or months amid the plethora of living things such a garden supports and never come to the end of new observations of nature at work and play. The plants are constantly changing and growing, with one coming into bloom, then another; tadpoles change into frogs, tiny swimming needles into colorful fish; dazzling dragonflies per-form aerial acrobatics as they hunt. Birds nest and feed, mate and migrate; bees buzz, and the world is alive with the sounds and sights of nature.

↑ The water garden is home to countless creatures who make their home and find their meals there.

Variations on a theme

The possible variations here are countless. Make a water garden, any size or shape, plant it, and watch a world come into being.

Where this style can be used

Though this is a rural setting, suburban sites would richly benefit from this approach—and, as we have seen, an urban environment can harbor the delights of a water garden as well.

Alternative garden designs with water

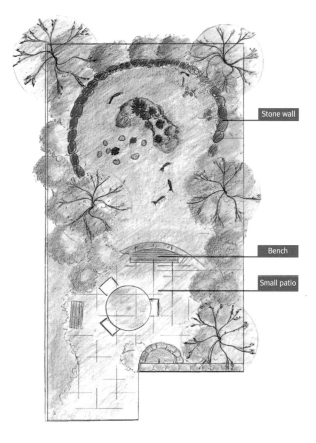

Stone wall

Bench

Small patio

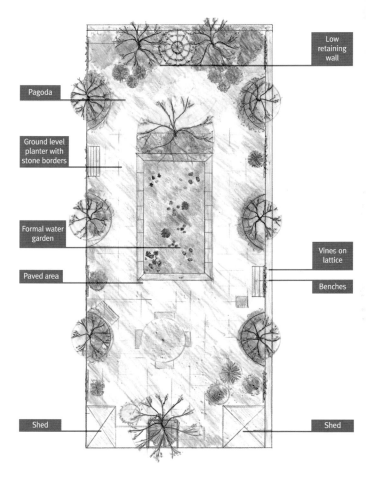

Low retaining wall

Pagoda

Ground level planter with stone borders

Formal water garden

Vines on lattice

Benches

Paved area

Shed

Shed

A small patio overlooks a large pond with a planted island and a backdrop of trees, shrubs, perennials, and ground covers. The pond laps the curving edge of the patio and a bench overlooks the water. A small, raised fountain is at the other end of the patio.

A large, formal water garden occupies the center of a paved area and is the primary element of the garden. Small planting areas are regularly spaced around the water garden, edged in the same stone that lines the water garden. Planted pots and other ornamental items are placed randomly about.

Directory of materials

A

Arbor A garden structure usually made of wood or iron used to join two distinct areas or to mark the transition into a garden. They are often arched but can be flat as well.

Arts and Crafts A style of design that originated in the late 1800s, characterized by distinctive craftsmanship in the working and combining of materials. Natural stone, hand-worked wood, wrought iron, and brick were favorite building materials, often used together.

Asymmetrical balance An arrangement that is not bilaterally symmetrical along any axis yet that is balanced.

B

Bamboo fencing Fence constructed of bamboo stalks.

Bark chips A ground cover made from the bark of trees, often pine, usually used as a mulch for planting beds but that makes a serviceable, informal ground covering.

Basket-weave A common pattern for laying brick in which bricks are laid in pairs, perpendicularly to those around it. Two bricks laid along the line of one axis will be surrounded by two bricks on one side, two bricks on the other, two bricks on top and two on the bottom, laid along the other axis.

Bluestone A type of sedimentary stone, typical of northeastern United States, used as a both an irregular and a regular rectangular flagging stone, ranging in color from browns and greens to blues and grays.

Brick Baked clay, usually rectangular-shaped and available in a variety of sizes and colors. One of the most ancient and versatile building materials, both inexpensive and easy to work with. In temperate regions in-ground brick constructions can be built without mortar. In colder regions, brick constructions are with mortar, usually with a concrete pad or a footing and foundation beneath.

Brownstone A brown-to-red metamorphic rock found in the northeastern United States and used for buildings and walls because of its ornamental value and ease with which it can be or shaped.

C

Casual, informal A style that deemphasizes intentional construction, focuses on natural elements, and is intended to generate a relaxed atmosphere.

Chozubachi A traditional Japanese stone fountain used for purification before entering a sacred place.

Clinker Brick burned in the firing process, characterized by black and blue-black, metallic looking areas.

Clipped box Boxwood (Buxus) clipped into forms or hedges.

Cobble A rectangular, quarried granite stone used in paving.

Common red brick The most common brick available, from which derives the term, "brick red." The term is going out of use in many stone yards, replaced by manufacturer's names or by a number designation such as 51.

Contemporary style A style characterized by clean, angular lines and man-made materials.

Contrast One method of combining materials, colors, and textures of forms is to juxtapose opposite or nearly opposite values, thereby creating dynamic effects by the principle of contrast.

Coping The capping put on walls, often of a different material, such as bluestone coping on a brick wall. The intent is to prevent water from penetrating the wall but provides an opportunity for ornamentation as well.

Counterpoint When contrasting elements presenting distinctly different values, such as when two planting groups of opposite textures or colors are placed within the same visual field, they can be said to be counterpoint to one another.

Courtyard A space enclosed on four sides, at least three of which are formed by the walls of the structure to which the courtyard belongs.

D

Decking The material, usually wood or a synthetic substitute, used to create a solid surface, often elevated, laid as boards in linear fashion.

Dry creek bed A bed of washed pebbles laid in the line and with the look of a stream but carrying no water.

F

Flagstone Any random, rectangular stone used for paving.

Formal fountain A fountain adhering to the below stated principles.

Formal A style of design characterized by symmetry, linear arrangements of space and balanced proportions.

Fountain court A court containing a fountain, often in the formal style.

Fountain A usually raised basin containing water into which water flows from a visible source in ornamental display. Also, the source or device itself from which the water issues.

G

Gravel Any of a wide range of small rocks used in construction and as informal paving.

Ground covers Plants that spread to cover areas of ground. Often such plants are evergreen and many take foot traffic.

H

Half wine barrels Wine barrels cut in half, often used as water gardens because of their capacity to hold water without leaking.

Harmony A relationship created between like elements or elements with some important attribute in common, such as two shades of a color or similar curves or closely related textures. An important consideration in combining two or more elements is whether or not they harmonize.

Hedge A wall made from living plants usually planted close together to create a solid screen. The plants chose for a hedge are usually narrow growing with a distinctly upright habit.

I

Informal patio garden A patio with plants, designed in a relaxed style, devoid of straight lines, usually asymmetrical and composed of natural materials.

Irregular flagging stone Paving stone of various, non consistent shapes and sizes.

L

Lattice fencing A web-work of wood slats assembled into sheets and built together to form a fence.

M

Mediterranean A style of design originating in the Mediterranean region, in architecture characterized by plain, stucco or plaster surfaces, barrel tile roofs, tile ornament, and wrought iron. Often such constructions contain a courtyard with planted terra-cotta pots and a fountain in the center of the court.

Mortar A cementitious material used to bind stone, brick, or other cementitious materials together.

Mosaic A pattern of any style created by the placement of individual components of stone, tile, wood, or any other material, usually set within another medium that serves as background to the mosaic.

N

Natural gardens Gardens that seem to have been made by nature, characterized by non linear arrangements of space, a seemingly arbitrary planting scheme and that convey a relaxed, informal impression.

O

Oriental garden A garden built upon the principles of Japanese and Chinese aesthetics of garden design. Both are built of natural materials with an emphasis on stone, plants, and water in combination. In the Japanese style, such gardens are more controlled, with great attention paid to detail. Chinese gardens are more natural, less contrived in appearance.

P

Parterre work Patterns made by the close placement of a given plant species in a particular design, often forming a low enclosure within which are grown other kinds of plants. Boxwood, (Buxus) is typically used for this purpose as it is evergreen, has a tight, neat habit, is easily clipped to retain size and shape and is slow growing.

Pavers Usually rectangular or round stone or more commonly, concrete pieces set into the ground with planted ground between, used as walkways or semi-informal patios.

Pea gravel Small, rounded stones between 1/8 to 1/2 inch (0.5 to 1 cm) in diameter used as an aggregate in concrete or as an informal paving material.

Perennial bed A planting bed consisting primarily of perennials. Also called a perennial border as such gardens are often used as a border to larger growing shrub plantings.

Pergola A small, outdoor seating area with a roof or lattice cover and closed or open sides with one side completely open. Often placed of the garden.

R

River stones Any of a variety of stones from several inches to several feet (8 to 91 cm) across that are smooth and rounded from the action of water over long periods of time. Useful in the creation of streams and natural ponds.

Running bond A common pattern of brick laying in which the bricks are laid in the same direction with staggered joints such that the end of each brick intersects the center of those to the right and left of it.

Rustic A 'homespun' quality of design and construction in which natural materials are employed without any attempt at sophistication or polish.

S

Sandstone One of several types of sedimentary stone giving rise to many types of flagging stone. Bluestone and Tennessee crab orchard are names given to two types of sandstone available for paving, and sandstone is one of several types of sedimentary stone.

Sculpture In the garden, sculpture can play an important role. In a very lush garden, a piece of sculpture placed within the planting can give balance and structure to what would otherwise be too overwhelming a display of nature.

Sense of 'place' A garden should always have a sense of place. The lack of it is like listening to a piece of music that has no consistent melody. It lacks coherency and, therefore, disturbs rather than pleases.

Slate Sandstone that has undergone heat and pressure over time becomes a metamorphic rock. Some forms of this are slate, often used as paving and, in times past, as roofing material. It is harder, flakier, and has more of a sheen than does the sedimentary sandstone from which it derives.

Specimen plant Plants, often small ornamental trees, that because of their particular beauty or distinctive characteristics are selected to occupy a prominent place in the garden, such as the center of a front yard, are so called 'specimen' plants. On the whole it is an unfortunate notion, playing a key role in an unfortunate style of design typical of American front yards in which there is 'foundation planting', a lawn and the 'specimen' plant.

Stone dust A mixture of small pieces of stone and the coarse to fine powder that results from grinding the stone, used as a base beneath flagging stone because it is both stable and firm yet drains well. Where a cement base is not used beneath stone paving, particularly in areas of freezing temperatures, stone dust is an excellent choice.

Stream More suitable for more gardens that many people realize. A well-made stream in the garden becomes a world of its own and can provide unimagined delights.

Structure Too often lacking in gardens is the element of structure. Plants need balance, and structures, of any and all kinds, can give the necessary balance foliage and flowers need to look their best.

Symmetrical Mirror image balance between a central line. The human being is bilaterally symmetrical along the vertical axis, asymmetrical along the cross axis.

T

Tapis vert Literally 'green carpet', the French term for an expanse of lawn.

Tennessee crab orchard A sedimentary sandstone used for flagging. Colors range from dark to light browns, into rosy reds.

Terra-cotta tiles Bisque fired clay rectangles usually less than 1/2 inch (1 cm) in thickness.

Terra-cotta pots Bisqued clay planting pots.

Texture The tactile quality of something due to its surface characteristics. An important consideration when combining materials.

Third dimension In gardens, up is the third dimension, frequently under considered in garden design.

Tiered The creation of ascending or descending elevations, particularly useful in maximizing the potential of a slope.

Topiary Shrubs and trees clipped into distinctive shapes or specific forms. Boxwood are often used for this purpose.

U

Unified composition A composition with a distinct and clear relationship between the parts of the whole wherein each part is formed under the same guiding principle or principles of the whole. In nature, we see this in the formation of the branching, the pattern of which is found in the formation of the leaves, the vanes of the leaves, the flower parts, and so on.

V

Velvet grey A type of sedimentary stone characterized by russet, beige, and gray tones and a sandy texture, used in veneer wall or dry wall construction.

W

Water feature Any fountain, pool, pond, tub, or bog or other man-made device for displaying water and or water flora and fauna.

Water gardens Usually refers to a man-made pool containing water and water life, as opposed to a wall fountain or bog garden.

Woodsy garden A garden designed to convey the sense of being in a woods, usually by the placement of trees and shrubs and the use of stone, water, or perennials in natural groupings.

Directory of designers

Photo credits

R. Todd Davis, 26

Keith Davitt, 3, 7, 9-13, 16-22, 42-43, 78-82, 84, 94-96, 98, 121-122, 124-130

©Guillaume DeLaubier, 4-5, 14, 25, 28-29, 62-63, 87, 90

©John Glover, 6, 30-31, 35-39, 40-41, 44-52, 55-61, 64-68, 71-77, 88-89, 92, 101-107, 111-116

Acknowledgments

My special thanks to photographer John Glover for his extreme cooperation in providing me with images and appertaining information and to my project manager Ann Fox, for her cool, cheerful way of handling the hot spots.

About the author

Keith Davitt has been designing, building, photographing, and writing about gardens for twenty years. His gardens and articles have appeared in numerous magazines, and he recently won the Herald Award for Excellence in Garden Communication. He is also the author of *Small Spaces, Beautiful Gardens* (Rockport, 2001). He lives in Cambridge, NY, and can be contacted through his Web site at www.gardenviews.com.